IMAGES
of Rail

LAKE SHORE
ELECTRIC RAILWAY

Avon Lake
cars #38 + 167
p64

IMAGES
of Rail

LAKE SHORE ELECTRIC RAILWAY

Thomas J. Patton
with Dennis Lamont and Albert Doane

ARCADIA
PUBLISHING

Copyright © 2009 by Thomas J. Patton
ISBN 978-0-7385-6123-3

Published by Arcadia Publishing
Charleston, South Carolina

Printed in the United States of America

Library of Congress Control Number: 2008936159

For all general information contact Arcadia Publishing at:
Telephone 843-853-2070
Fax 843-853-0044
E-mail sales@arcadiapublishing.com
For customer service and orders:
Toll-Free 1-888-313-2665

Visit us on the Internet at www.arcadiapublishing.com

CONTENTS

ACKNOWLEDGMENTS

This project is the product of background and knowledge gleaned from a number of publications, collections, and firsthand remembrances.

Although my family has lived in Avon Lake for over 30 years, it was not until my wife and I purchased the old Beach Park station in Avon Lake that we gained an appreciation of the significance of this property and how it fit into the development and history of Ohio's north coast. I began to purchase photographs, film, memorabilia, and any publication that I could locate about the Lake Shore Electric Railway and Beach Park.

Some of my inquiries allowed me to become acquainted with two excellent gentlemen that have an intimate and accurate knowledge of the operation and history of the Lake Shore Electric Railway—Dennis Lamont and Albert Doane. These two outstanding rail enthusiasts have provided more than assistance, they have allowed me to both learn and share a small portion of their vast knowledge and photographic collections. I would not be able to guarantee the accuracy of this book without Dennis Lamont. To show my appreciation, I am donating all royalties from the sale of this book to the Lorain Street Railway (a 501-c-3 nonprofit corporation). One of the Lorain Street Railway's goals is the restoration of Lake Shore Electric No. 167, the last revenue passenger car to operate on the Lake Shore Electric and prominently shown as the last image in this book. Earlier volumes authored by Spangler and Toman, Harry Christiansen, James Blower and Robert Korach, William Middleton, George Hilton and John Due, and Herbert Harwood and Robert Korach have been cross-referenced and incorporated in this publication.

Lastly, photographic acknowledgement must be issued to James Spangler for his kind participation in allowing use of images in his vast collection. Our Arcadia Publishing editor, Melissa Basilone, has been superb in managing us in this interesting project, which rounds out our list of credits and notes of appreciation.

Thomas J. Patton
Avon Lake, Ohio

INTRODUCTION

For over three decades, the electric interurban railways played a major part in the economic life of the Midwest. As a transitional step from main-line railroads to the automobile, bus, and truck for short distance travel and small-lot shipment, it provided a substantial contribution to the economic development of the area. The story of its meteoric rise and equally sudden demise, and of the role it played in the transportation picture of its day, is a drama rarely rivaled in the economic history of the country. Interurban railways were built in all parts of the United States. Their development reached the highest stages, and their contribution to the economy was greatest in four Midwest states—Ohio, Indiana, Michigan, and Illinois.

The typical interurban was characterized by four features: electric operation, primary emphasis on passenger business, use of cars heavier and speedier than city streetcars, and extension beyond the limits of one city or metropolitan area.

Intercity electric lines were direct outgrowths of city street railway systems, and development of electric traction in the 1880s resulted in rapid replacement of cable and horsecar lines and rapid construction of many new routes. It did not take long for the city streetcar lines to reach their operating limits, a one-hour ride averaging 10 miles per hour. Extensions into the suburbs and in between towns required a different type of electric car. They were built in almost all cases on public road rights-of-way using lightly constructed track with speeds and distances limited by primitive power systems.

When the Sandusky, Milan and Huron Railway commenced, in 1893, we finally view evolution creating a true interurban. Separate rights-of-way were obtained, usually paralleling roads or steam railroads, and stations were built. Longer, heavier cars, often with express compartments, were designed specifically for high-speed intercity operation, and package freight and express business was cultivated.

Progress was slow in the 1890s, but at the dawn of the 20th century a great boom in interurban construction developed, and by 1910, the systems were largely completed. New companies were chartered; stock sales were promoted; and lines spread rapidly between the major cities and towns, sometimes requiring cooperative links to connect adjacent systems. Some of the lines were poorly conceived, with little analysis of traffic potentialities and duplication was not uncommon. Every town was determined to have a railroad in the 1860s and 1870s, and every town was determined to have an interurban at the dawn of the 1900s. Diverse interests were involved in the development and financing of the companies, such as railroads and electric power facilities. Power companies were interested because this was a time when small towns and rural areas were not electrified and the power created by the interurban power grid allowed

the introduction of electric power to these rural residences and businesses. The lines between interurban companies and electric power companies often became blurred, which is clearly the case of the Lake Shore Electric Railway, Cleveland Electric Illuminating Company, and Cities Service Company. Many of the interurban companies were developed by independent local interests, and those interurban companies typically supplied local transit service in the smaller cities they operated through. In the case of the Lake Shore Electric, when the railway collapsed, the management was operating the Lake Shore Bus Lines.

By 1915, about 7,500 miles of interurban track, the equivalent of two lines from New York to San Francisco, extended through Michigan, Ohio, Indiana, and Illinois, with a few hundred miles in Wisconsin. Of these states, Ohio had the most mileage (2,780), followed by Indiana (1,798), Illinois (1,590), and Michigan (1,027). These are figures from the U.S. Department of Commerce's Census of Electric Railways in 1917; the figure for the entire country was about 18,000 miles.

The development of interurban operations culminated in the major interchanging routes in the Midwest. The Lake Shore Electric Railway operated routes from Cleveland to Detroit, via Beach Park (Avon Lake), Lorain, Sandusky (joining with ferry service to Cedar Point), Toledo, and on to Detroit. Passenger traffic moving east to Cleveland often continued on to Erie and Buffalo (Niagara Falls) via affiliated steamship service. There were both affiliated and nonaffiliated routes that a passenger could access, if they wished to travel from Cleveland to Akron, Canton, Pittsburgh, and Wheeling. Travel to points farther south in Ohio were available through the Cincinnati–Cleveland routes, one via Springfield, Columbus, and Delaware and the other via Lima and Findlay. Travel from the southern point of Cincinnati allowed Indiana access via a branch from Lima to Fort Wayne. Development of the east–west route from Terre Haute to Indianapolis, Dayton, Springfield, Columbus, and Zanesville, along with its alternative routes, operated between Indianapolis and Dayton via Richmond and Muncie. The north–south route from Louisville via Indianapolis and Kokomo to Elkhart and South Bend, with a connection from South Bend to Chicago, served population centers in Indiana and continued the electric transit network. The Indianapolis–Fort Wayne, Fort Wayne–Lafayette, and Lafayette–Indianapolis lines operated most of the Indiana lines and were important interchange partners for all the adjacent lines. Movement of the Michigan routes, which ran a north route from Detroit to Flint and Bay City, and an east–west route from Detroit to Jackson, Lansing, and on to Battle Creek, Grand Rapids, and Muskegon. One hundred years ago, Cleveland was the fifth-largest city in America; however, Chicago was even larger and the routes out of Chicago, eastward to South Bend; northward to Milwaukee and Sheboygan; northwestward to Rockford, Janesville and Freeport; and westward down the Illinois Valley to Princeton served this large population's travel. Not to be forgotten, the adjacent Illinois Traction System from Danville and from Peoria via Springfield to St. Louis was a popular Midwest operation.

Most people today believe that train travel 100 years ago was by steam rail systems, such as the Baltimore and Ohio (B&O) Railroad, Chesapeake and Ohio Railroad (C&O), and so on. However, a memory of the interurban needs to be maintained to recognize the important contributions made by this short-lived enterprise to the expansion of urban life in industrial-era America, and specifically for this publication, northern Ohio.

The easiest piece of this story to tell is how one could travel by interurban from virtually any location in America to any other by these clean electric railways. Certainly, most truly long-haul travel was accomplished by steam rail, due to the multiple interchanges required and because the interurbans were slower than the steam railroads, due to frequent stops designed to accommodate the on/off short-haul needs of passengers and freight that made up the clientele of the interurban system.

Roughly 150 separate interurban companies were in operation in the peak years in Ohio, Michigan, Indiana, and Illinois. Much of the mileage was concentrated in the hands of a relatively few companies. The Illinois Traction System and its affiliate, the Chicago, Ottawa and Peoria Railway, had about 700 miles, or approximately half the total. The Terre Haute,

Indianapolis, and Eastern Traction Company and the Union Traction Company of Indiana, each with over 400 miles of line, operated a large portion of the Indiana mileage. Two companies ran most of the lines in Michigan.

The basic features of interurban operation did not change greatly over the three decades the lines were in existence. Single-car trains were the standard operating unit, with multiple cars normally confined to excursions and rush-hour operation, out of large cities. Two-man crews were the typical staffing, which, when combined with the relative absence of restrictive operating rules, kept costs per train mile far below that of the steam railroads. Wooden cars, with their clerestory roofs, elaborate colored glass, and cane seats, gave way to new steel cars with plush seats. Track standards were improved and automatic signaling systems were installed, making travel by interurban comfortable, fast, and inexpensive.

By 1910, the interurban had become a major element in the transportation picture of the Midwest. Passenger service accounted for approximately 80 percent or more of total revenues, and freight, while highly marketed, never materialized as a major income stream. The interurbans' most important contribution was efficient and speedy service between rural areas and small towns and adjacent cities, breaking down the isolation of farms and small villages. Frequent service with numerous and convenient stops facilitated travel to market, to school, and to entertainment. The trend toward shopping in larger centers in preference to rural and village stores, which became so marked after the development of the automobile, was commenced by the interurbans. A shopping trip to a city 30 miles away became a simple and routine matter instead of a major and time-consuming excursion. Likewise, the benefit of easy access for weekend trips to the country, beach, or amusement park was due to the fact that many interurban companies developed the countryside amusement parks and resorts.

The interurban became the standard means of travel between the larger cities served, up to a limit of about 150 miles, although there was some longer distance travel. As a consequence, the steam railroads lost a large portion of their short-line travelers. While the interurban may have been slower on the long runs and somewhat less comfortable, the advantages of more frequent service and conveniently located stations proved successful. As comparatively long-distance travel increased, parlor cars were added and limited-stop schedules were incorporated into the scheduling (express lines). Another asset of the interurban was informality and avoidance of the impersonal nature of main-line railroads. The usual practice of running into the downtown areas of cities was a convenience, particularly for the shopping traffic, but was a serious source of delay for long-distance travel. In almost all cases, city streetcar tracks were used, so speed in getting into and out of larger cities was drastically limited to that of the city cars. Once in the country, however, the speed performance was good despite frequent stops and light track. High acceleration plus speeds up to 70 and 80 miles an hour allowed the interurban railroad car to average 30 to 35 miles an hour over an entire schedule.

As previously noted, freight business was not of much importance to most interurban lines. However, the Lake Shore Electric was an exception, possibly due to the rapid growth of steel and manufacturing in Lorain, Elyria, and Cleveland, plus the easy access between the industrial areas of each city via Lake Shore Electric lines. Along with the industrial freight and package freight, a great deal of farm produce and fish was moved from Vermillion and Lorain to Cleveland. One must remember that Lorain was principally a fishing town prior to Tom L. Johnson's construction of his steel mill in South Lorain.

Interurban systems were quicker, easier, and usually cheaper than steam railroads, and they did pursue the less-than-carload business that the railroads were beginning to shun. By providing same-day delivery of goods, the distribution of perishables became easier to accomplish. Again, we have to remember the large amount of fish shipped to Cleveland from Lorain and Vermillion.

Few industries in the history of the United States have ever collapsed with the speed at which the interurban systems came to an end. In the 15-year period from 1927 through 1941, the great network built up in the previous 20 years had all but vanished, and most of the lines were abandoned between 1929 and 1937. Not a single mile of the great Ohio–Indiana–Michigan

network, except the line from Chicago to South Bend, remains in passenger operation today, and only about 40 miles of track out of the original 6,000 are still in use in freight service.

The most commonly quoted and undisputedly a huge factor in the demise of the interurban systems was due to the advent of affordable internal combustion vehicles and a comprehensive system of all-weather roads. A whole industry grew up around buses and trucks that appeared cheaper to operate, with no track maintenance or external power source. A simple road tax levied per gallon of gasoline replaced taxes to state and local officials. The interurban companies themselves began to use buses on otherwise unprofitable routes.

The automobile was invented in roughly the same period as the interurban, but the latter progressed much more rapidly. Electric motors were simpler than automobile engines and were perfected more quickly, while mechanical difficulties and the lack of good roads held the growth of the automobile to a snail's pace for 25 years. Meanwhile, the interurban network was built, and millions of dollars were invested in the industry with little thought to the competition coming from the growing automotive industry.

Even as early as 1910, automobiles and jitneys were commencing to make inroads to passenger travel to such an extent that few interurbans were built after that date, but the effects were not serious until after World War I. The jitneys were the first buses—usually large automobiles with seats added—operated mostly by individuals in city and suburban service on best traffic routes. As early as 1915 they were a serious headache to transit systems, but regulation soon put them out of business and the streetcar reigned supreme in city transit service for another 15 years. World War I aided in the advancement of motor vehicles, due to technological developments required by the military, both for automobiles and airplanes. The decade of the 1920s saw the primary transition to the motor vehicle. By the end of the decade, the effects on interurban business had become so serious that many small lines plus a few important ones had been abandoned, and doubts about the future of the industry were arising. In general, however, the system was largely intact in 1930. The most important lines abandoned before 1930 were the western lines of the Michigan system.

The final big blows against the industry were dealt in the 1930s, when the combination of the Depression and the continued growth of the automobile caused such a drastic drop in interurban revenues that in many cases they fell below operating cost.

All interurban lines, including the Lake Shore Electric, have vanished so completely that they are almost forgotten. In most cases it is difficult to trace the old interurban paths, but when walking through the Metropark in Bay Village, behind the service department, you will see the skeleton of a Lake Shore Electric bridge. In Vermilion, you can see the remnants of Lake Shore Electric car No. 38, serving as a storage unit for the Vermillion Gun and Fish Club—originally placed when bankruptcy made this freight car available in 1938. In the crawl space of Artstown (the old Beach Park station and carbarn) you will find old track and other mementos of bygone days.

One

CREATION AND
EARLY OPERATION
OF THE RAILWAY

In the fall of 1901, the Everett-Moore Syndicate, a Cleveland-based collective of approximately 85 investors led by the managers Henry Everett and Edward Moore, created the Lake Shore Electric Railway (LSE), which was just one of their investments. Much like today, this was an era of merger, consolidation, and nonorganic corporate growth. Thus, the Everett-Moore Syndicate purchased controlling interest in a number of electric railway lines within northern Ohio and consolidated them as the LSE.

At least five separate operating lines were pieced together by the Everett-Moore group to form the original LSE: the Sandusky and Interurban Electric Railway; Sandusky, Norwalk and Southern; People's Electric Street Railway in Sandusky; Norwalk city operation; and finally the Toledo, Fremont and Northern (TF&N).

To understand the origins of the LSE, one has to remember that in 1890 a company was organized to build a streetcar line in Lorain. This entity was named the East Lorain Street Railway. In 1897, the East Lorain Street Railway was taken over by a group that was financed by the Everett-Moore syndicate, and also, in 1897, the name was changed to the Lorain and Cleveland Electric Railway (L&C). The L&C built a carbarn, powerhouse, and resort area at Beach Park, a community within the town of Avon, located conveniently between Lorain and Cleveland.

In 1898, the Everett-Moore Syndicate took formal control of the L&C line and commenced the "roll-up" of interurban lines that allowed a continuous line from Cleveland to Toledo. The Cleveland to Toledo Railway came near to fruition in late fall 1901, when the L&C became a part of the LSE.

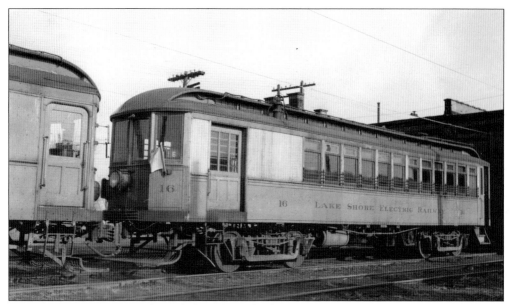

LSE No. 16 is a Barney and Smith (B&S) car, built in 1900. This unit is back from Cleveland and is headed on to the Sandusky shop for scrapping. The white flag denotes that the car is not on a scheduled run. This photograph was taken at the Beach Park station in 1938.

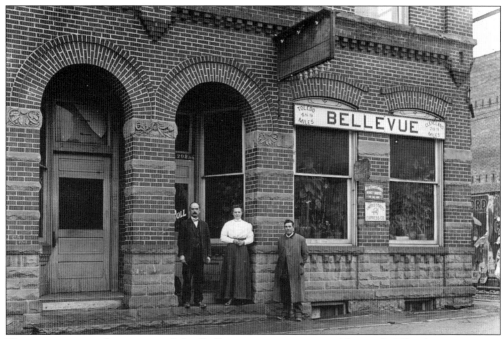

This is an outstanding image of the Bellevue station agent and his wife. This location was a leased storefront with package delivery space in the rear. This building burned to the ground in 1973.

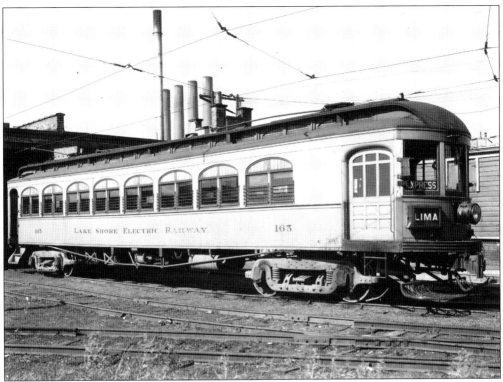

LSE car No. 165 is pictured here on a clear day facing east with the power plant stacks in the background. This photograph was taken at the Beach Park station before 1937, as the headlight is still high and there are no under-floor lights.

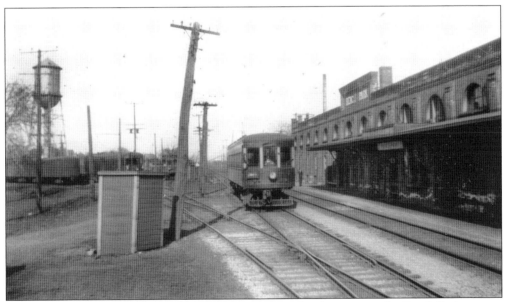

This is an early image of a Jewett car on the Lorain run, heading west at the Beach Park station. The LSE water tower, which was fed by the LSE water plant farther to the north, is seen in the photograph.

This is a 1907 photograph of Avon Center. Avon split into two towns in 1917: Avon and Avon Lake. The LSE did not enter the area currently known as Avon. However, when the operation commenced, all records noted Avon. One interesting feature of this photograph is the advertisement on the bench, which notes, "Kuntz Co—Lorain at the 'Loop.'" The loop was built in 1894 by Tom L. Johnson, for his Lorain Elyria line.

The land adjacent to the LSE tracks consisted of grapes and dirt roads in 1902. This is Lake Road in Avon Lake, showing the development markers for Mull Road on the right and North Point Drive on the left.

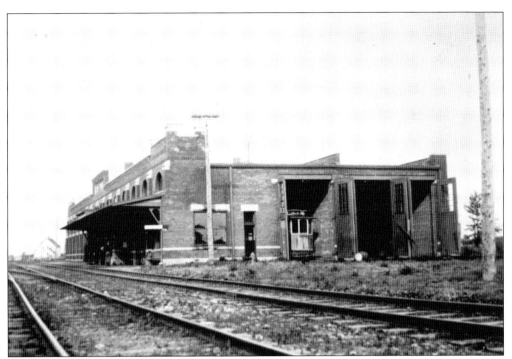

This is an early photograph, as there is no upper window above the large window to the left. The Beach Park station was initially built by the L&C line and came to be LSE with the Everett-Moore Syndicate.

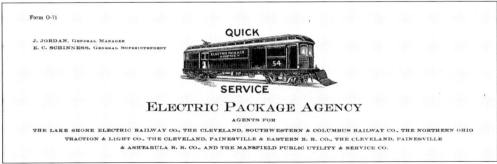

The participating partner interurbans are shown on this Electric Package Agency (EPA) letterhead.

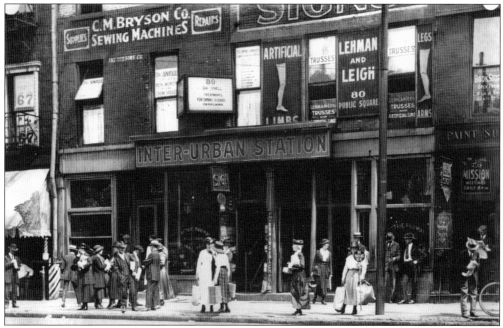

The "old" interurban station on the southwest corner of Public Square in Cleveland is seen here. Shoppers, commuters, and other travelers are waiting for the next car. The 1910 *Cleveland Interurban Guide* lists seven interurban lines running east, west, and south out of the city center.

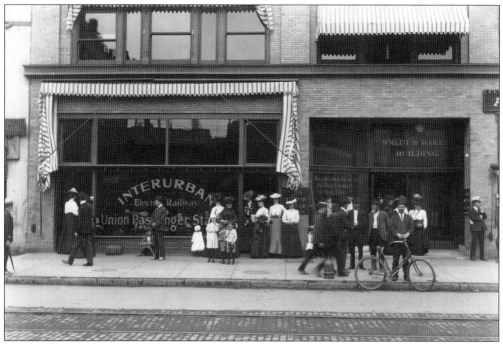

This photograph of the Superior Street interurban station in Toledo shows men, women, and children waiting for the next interurban car. When this picture was taken, Toledo was served by 10 interurban lines radiating out in all directions from the city center.

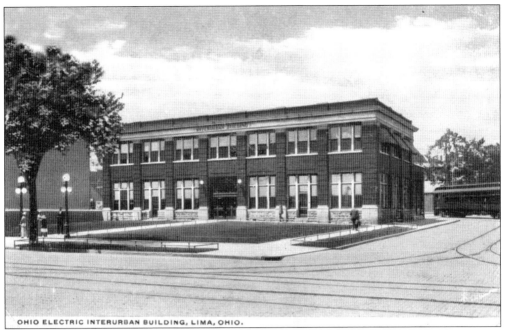

OHIO ELECTRIC INTERURBAN BUILDING, LIMA, OHIO.

The interurban station at Lima is pictured here. During the time of the LSE's participation in the Lima route, the LSE and/or Western Ohio Railway cars would leave Cleveland, transfer to the Toledo, Fostoria and Findlay Railway (TF&F) at Fremont, and run over the tracks of the Western Ohio Railway to Lima. This service ended when the Western Ohio and the TF&F ceased operations on January 6, 1932.

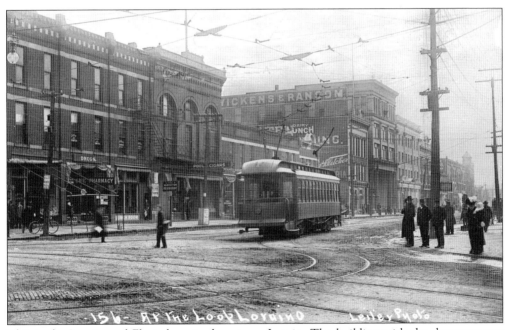

This is the Lorain and Elyria loop in downtown Lorain. The building with the drugstore was the Wagner Block and was destroyed during the devastating 1924 tornado, along with much of Broadway in Lorain.

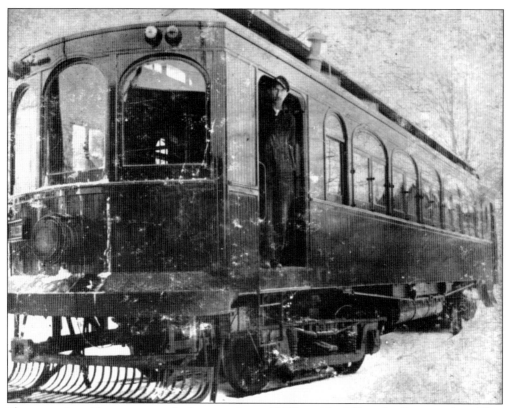

Shop man Jesse Trego poses at the baggage door of LSE car No. 162 at the Fremont shop. This shot of the Niles car in its original configuration is enhanced by the pair of trucks that one would normally see under a B&S car.

This photograph, taken in 1898 at the Beach Park station, shows an L&C car heading west to Lorain. In 1898, this was an L&C property.

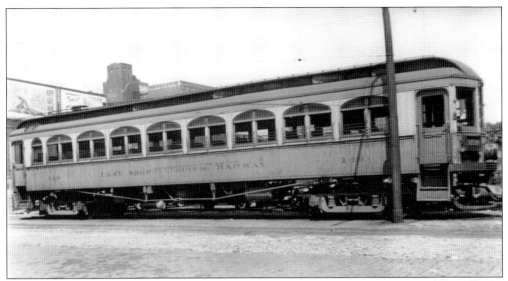

Car No. 149, one of the "big" Niles cars, was extended to 60 feet in 1923 so it could handle the large passenger loads necessary to work the Cleveland-to-Lorain runs and school bus runs. The Cleveland-to-Lorain operation was the most profitable service ever handled by LSE, and it was profitable right to the end of the line.

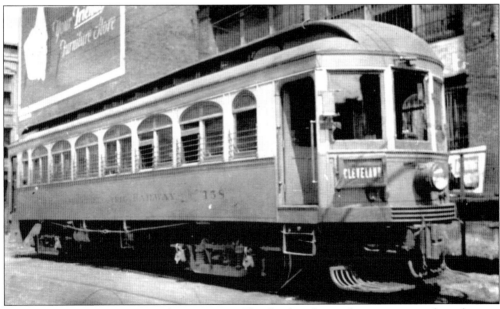

LSE car No. 158 is seen at Eagle Avenue in Cleveland and must have just arrived, as the sign still notes "Cleveland." This photograph was taken prior to 1937, as the headlight is still high, there are no under-floor lights, and passengers boarded at the rear only. The wide front door handled light package freight and newspapers. The interurbans were not handicapped accessible at this time.

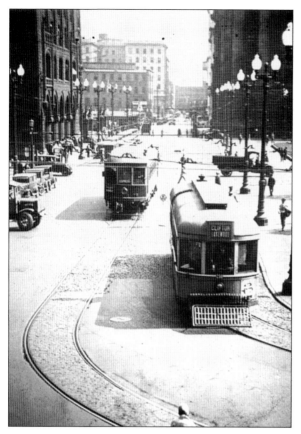

LSE car No. 163, a Niles combination car, is travelling on Cleveland's Public Square. The turn shown is the track to the LSE Cleveland station. The view is looking east at the north side of the northwest quadrant of Public Square. Of interest is the Society for Savings Building, which sports the first outdoor light in America, created by Brush Electric and installed in 1879 on the southwest corner of the building (where it is still located).

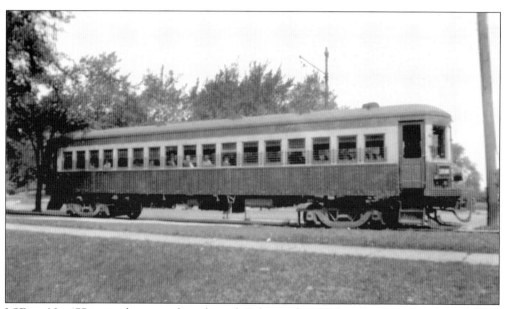

LSE car No. 177 is seen here traveling through Lakewood on Clifton Boulevard eastbound. This is one of the "big" Jewett cars, and, as was usual, it is full of passengers.

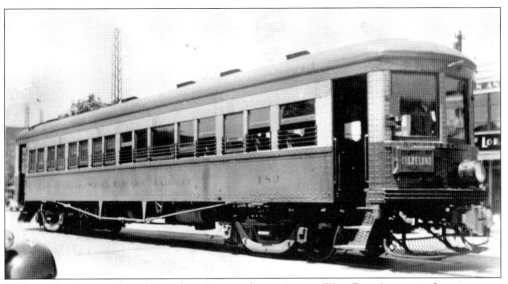

LSE car No. 183 travels eastbound, waiting at the station on West Erie Avenue in Lorain.

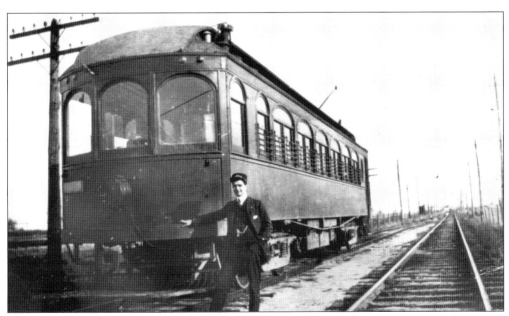

An enthusiastic young conductor poses with LSE car No. 150, still in its factory configuration, on a passing siding out on the western end of the line, probably around 1910.

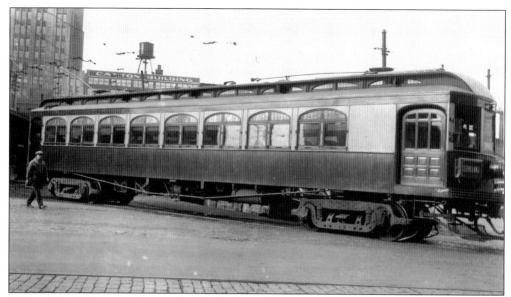

LSE car No. 165 is seen here at the Eagle Avenue freight yard. In the background are the Bell Telephone and the Caxton Buildings. Among the last of the interurbans built of wood in the Gothic style with curves, arches, and stained-glass windows, LSE car No. 165 served from 1911 to 1935, when it was wrecked in a tip-over accident and was never repaired.

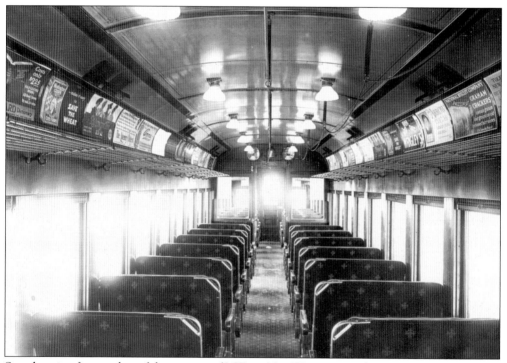

Seen here is a factory shot of the interior of LSE car No. 170 as it came from Jewett Car Company. This shows the original Hale and Kilburn flip-over seats common in interurban and railroad cars at the time. This is the passenger section looking toward the front and the partition that separates the smoking compartment from the rest of the car.

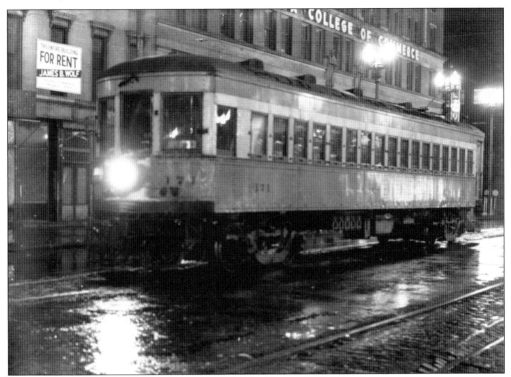

LSE car No. 171 poses for a rainy evening shot at the Cleveland interurban station in the southwest quadrant of Public Square in Cleveland.

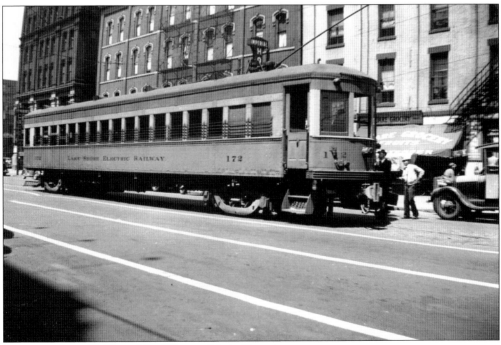

Passengers board LSE car No. 172, possibly in Detroit.

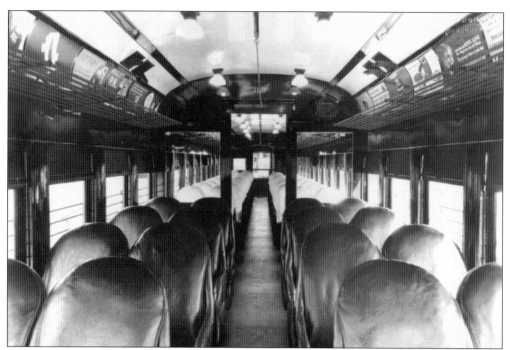

The interior of LSE car No. 179 is seen here after a 1925 rebuild that included bucket seats, leather in the smoker, and plush with white seat covers in the passenger compartment. The white seat covers were discontinued shortly thereafter.

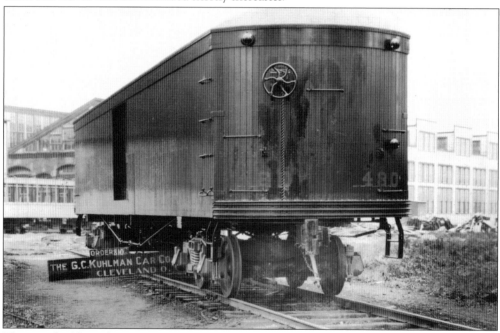

This is a builder's photograph of LSE car No. 430, a brand-new boxcar at the Kuhlman Car Company factory in Cleveland. This car would be transferred over the Cleveland Railway plant connection and delivered to the LSE in Cleveland. This was part of LSE's expansion of freight business after World War I.

A motorman, a conductor, and a couple of rubberneckers pose with LSE car No. 452 while the rest of the crew is hard at work on the overhead.

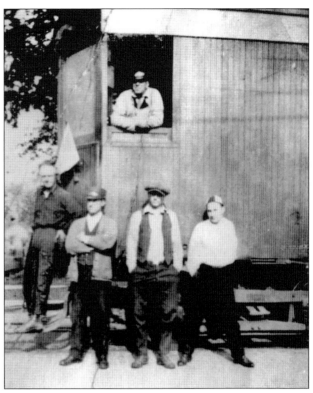

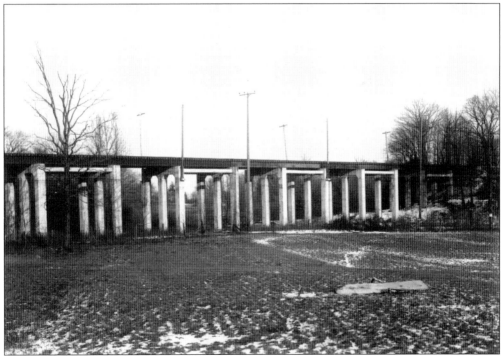

This picture was taken shortly after the concrete trestle went into operation in 1925, when the river bottomland was still farmed. The area is now covered with a dense forest.

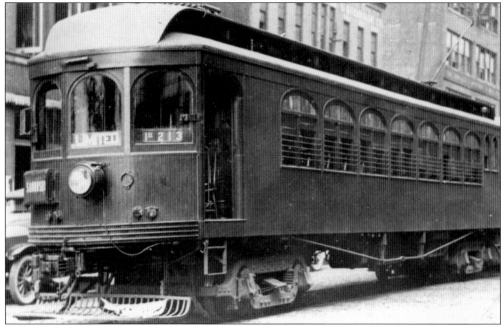

LSE car No. 166, in its pre-1925 paint scheme, sits on the layover track on West Third Street in Cleveland. The train number box shows it to be the first section of train No. 213. On the 1913 timetable, train No. 213 was a limited train leaving Cleveland at 1:30 p.m., arriving in Toledo at 5:50 p.m. and Detroit at 8:00 p.m.

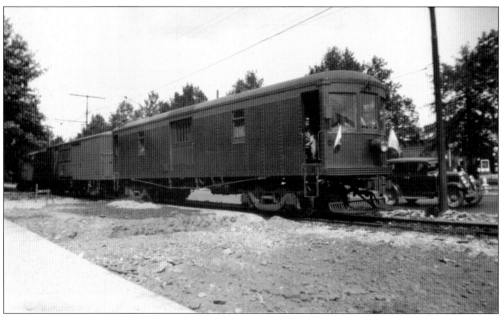

An LSE freight train rolls down the tree lawn on Clifton Boulevard on Cleveland's west side heading to the terminal at Eagle Avenue.

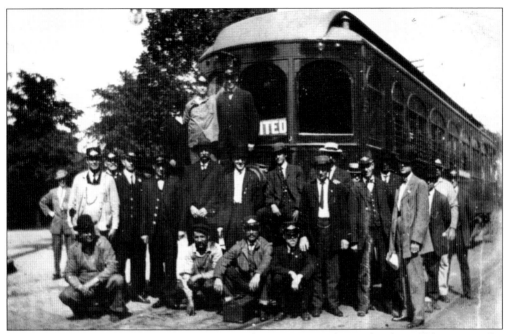

In Fremont, a whole cross-section of LSE employees pose in front of a shiny Niles car in the early days of operation. Bosses, foremen, shop workers, motormen, and conductors typify the camaraderie of the LSE employees that kept them together as a retirees group well into the 1980s.

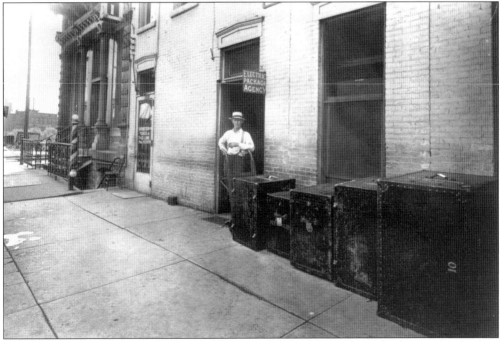

For a short time, the LSE rented a store across the street from the Wheeling and Lake Erie Railroad (WLE) station. In the back was the storeroom for the EPA. The picture shows the EPA agent preparing a string of theatrical trunks for shipment.

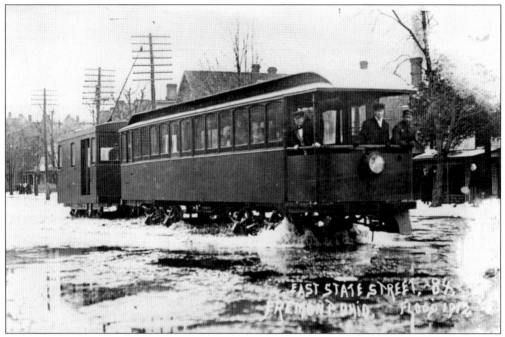

This is how the LSE passengers got through the 1912 floodwaters in downtown Fremont, with a floor-mounted motor in the shunter and a former Lorain–Elyria car with the motors removed.

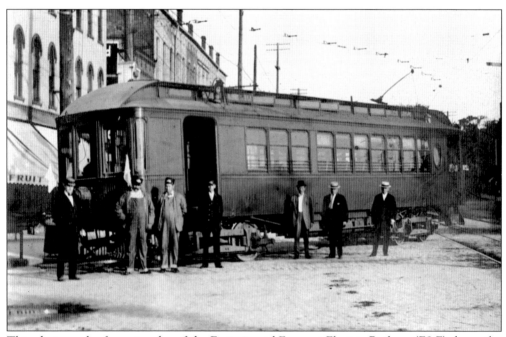

This photograph of opening day of the Fostoria and Fremont Electric Railway (F&F) shows the LSE crew on the borrowed LSE car used for the initial run (note the white flags) from Fremont, where this photograph was taken, to Fostoria. Car No. 63 was used for this celebratory run.

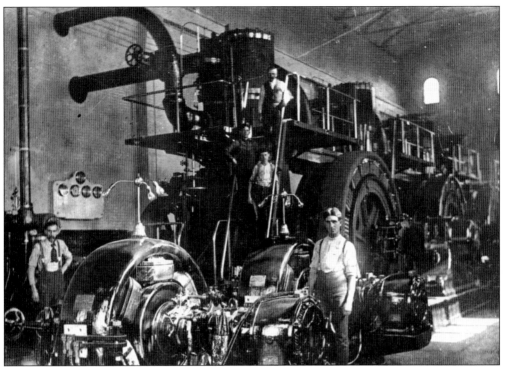

This is the engine room of the Fremont powerhouse, showing four vertical steam engines and generators for high-voltage alternating current for transmission. In the foreground are the rotary converters used to produce 600 volts direct current from the alternating current for interurban power. This coal-burning plant built in 1900 was replaced by a hydroelectric plant upriver at Ballville in 1916.

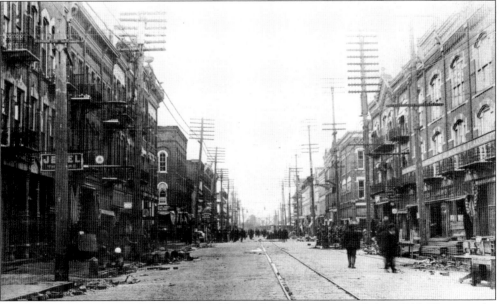

South Front Street in Fremont is pictured here after the waters receded in 1913. This was the F&F track to Fostoria, the line the LSE used on the Lima route and the Fremont streetcar.

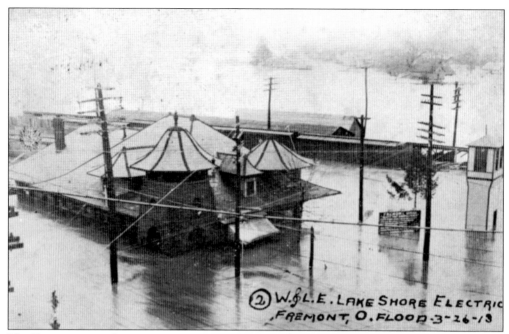

The Fremont interurban station was not open on March 26, 1913. This documentary photograph evidences the significance of the flooding and damage in 1913.

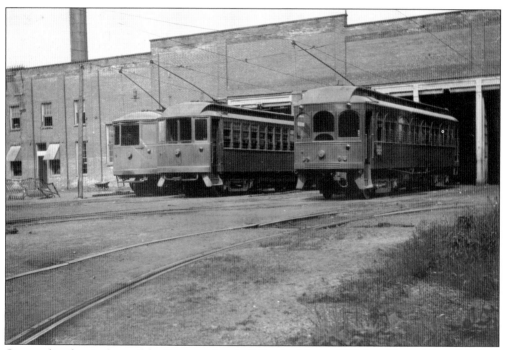

Cars are lined up in front of the Fremont shop building in this pre-1925 shot. From right to left they are a Niles car, a B&S car, and a rare shot of a B&S freight motor with a three-window end.

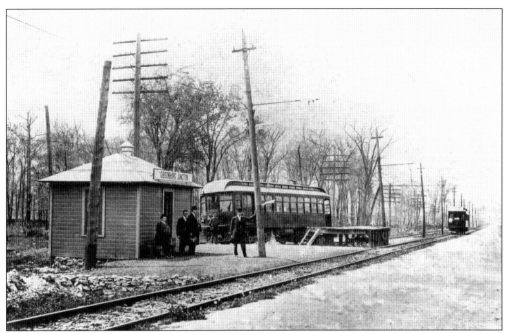

Stop No. 297½ was at the Gibsonburg Junction in 1909. Car *Beta*, originally from the Sandusky and Interurban Electric Railway, waits to pick up passengers from the approaching eastbound car.

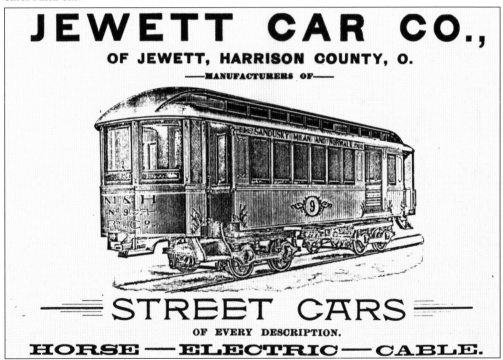

JEWETT CAR CO.,
OF JEWETT, HARRISON COUNTY, O.
—MANUFACTURERS OF—

SANDUSKY MILAN AND NORWALK

M S & H
No 9
R Co

9

STREET CARS
OF EVERY DESCRIPTION.
HORSE — ELECTRIC — CABLE.

This very early Jewett Car Company advertisement shows Sandusky, Milan and Norwalk Railway (SM&N) car No. 9, built in 1893. This was before the company moved its factory to Newark, Ohio.

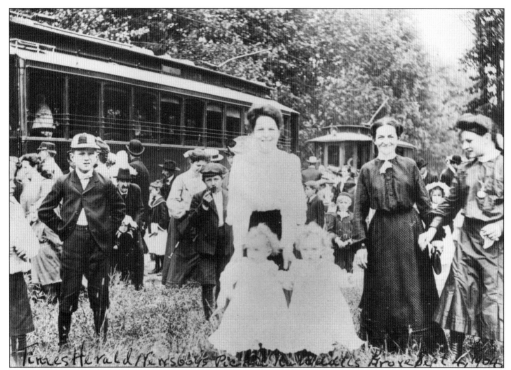

The date is September 4, 1904, and the *Lorain Times Herald* newsboys are at long-gone Randall's Grove near Root Road in Lorain. City streetcars from Lorain Street Railway were chartered to make the trip into the wilds of the countryside.

This early view of the intersection of Erie Avenue and Broadway shows the Lorain and Elyria line loop and the western terminus of the L&C line before there was an LSE. The area today is still known as the loop. Lorain's first interurban station is directly behind the L&C interurban car sitting at the end of the rail.

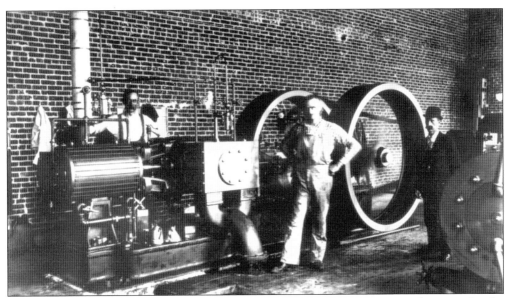

This is one of the two steam engines that were belted to generators to provide power for the SM&N at the powerhouse in Milan. Beginning in 1893, this plant was quickly rendered obsolete when the LSE took over.

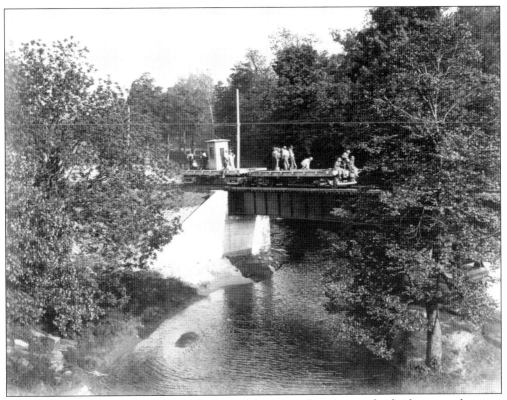

This picture, taken in the very early days, shows a work train on the bridge over the river in Monroeville.

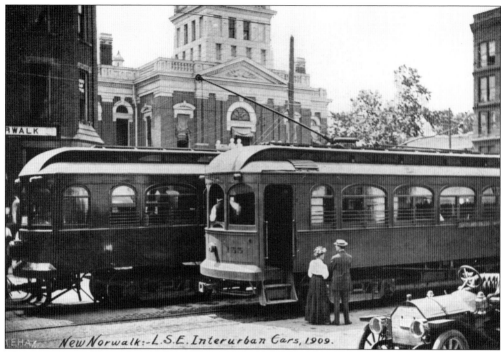

New Norwalk:-L.S.E. Interurban Cars, 1909.

This scene is at the LSE station in Norwalk in 1909. There is an eastbound and a westbound car. Although both cars are Niles, built at the same time, the car to the rear has a much better paint job than car No. 153 in the foreground. LSE car No. 153 was destroyed in a wreck in 1914, and the trucks were used under LSE car No. 167 in 1915.

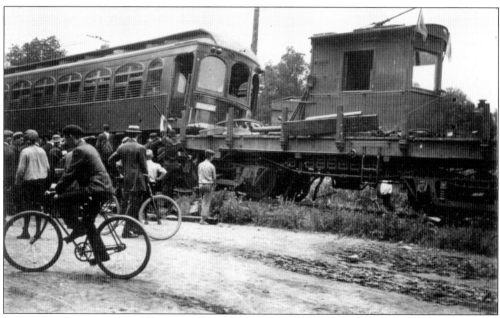

Failing to take a passing siding caused this collision outside of Norwalk on July 3, 1903. The work crew is trying to pry the two loose so that they can be separated, while there is no shortage of rubberneckers to advise.

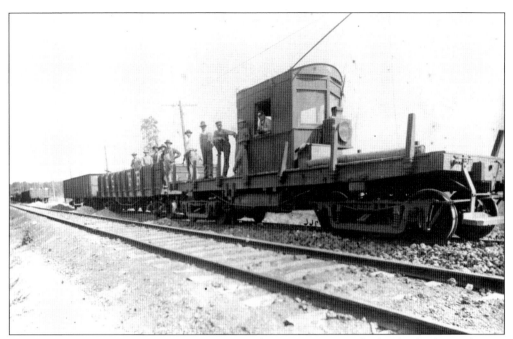

The 1906 photograph is of the LSE right-of-way between Lorain and Cleveland. The track gang laid the second track, and this crew hand shoveled rock ballast over the track to support it. Motorman Clyde "Beaver" Green is supervising as he rests his elbows on the windowsill of the work motor.

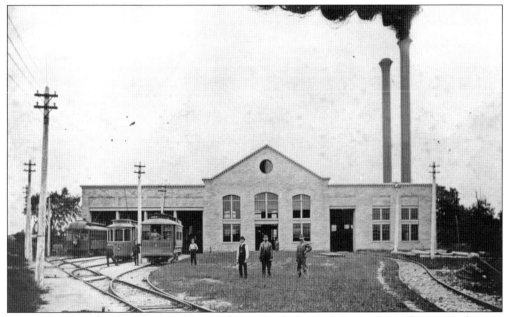

The original carbarn and powerhouse of the Sandusky and Interurban Electric Railway is pictured here. It was the home of *Alpha*, *Beta*, *Gamma*, and *Delta* interurban cars and the city streetcars of the system. Shortly after it was absorbed into the LSE, the old-fashioned direct current powerhouse was shut down and the site expanded to become the Sandusky shops of the LSE.

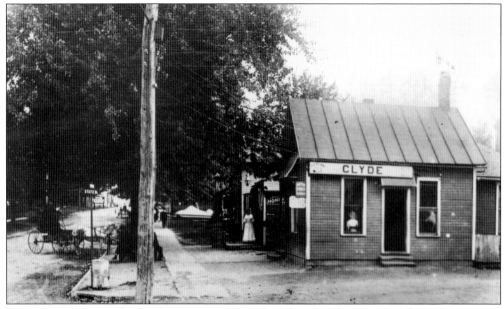

Stop M in Clyde was the first LSE station. It later bought a farmhouse across the street to put in a siding and freight house.

This photograph documents Mrs. Russ bringing lunch to the obviously well-fed Cal Russ. Cal was the motorman on LSE car No. 15 at the time, which was one of the B&S units constructed in 1900.

Two

INTERESTING ASPECTS
OF THE OPERATION

The financial and operational cast of characters is numerous and fascinating, having been introduced to most of the "big guys" involved in the creation and growth of the system earlier in this book. Hopefully readers will find the staff that was the backbone and soul of the railway interesting. One such fellow is William G. Lang, a motorman who risked his life to save a 22-month-old child who wandered from her home and onto the LSE track in Lorain. Motorman Lang was 52 on August 24, 1932, when he saw the child, Leila Smith, sitting between the tracks. He slowed the railcar, and actually stepped to the outside of the car, held on to the fender and found a way to grasp Leila's hands and hold her for the next 180 feet, which was needed for the conductor to finally stop the car. Lang was disabled for 12 days due to a back injury, and Leila sustained a leg fracture and head lacerations, but she did survive.

For his heroism, William Lang received the Carnegie Medal and was personally presented with an Interstate Commerce Commission Award by Pres. Franklin D. Roosevelt.

The images in this chapter show some of the special equipment used by the LSE, much of which was actually designed and built in the LSE shop in Sandusky. Also, the stations, stops, and fascinating features are displayed to allow some understanding of the depth and breath of the operation.

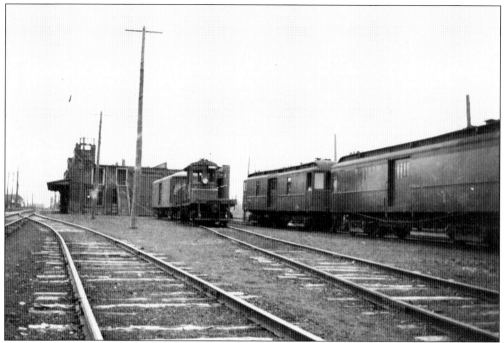

The year is 1930 and work motor No. 404 is switching a freight trailer out of the barn next to two freight motors at the Beach Park station. The majority of freight equipment was stored north of the carbarn, and these tracks were used for access to maintenance facilities.

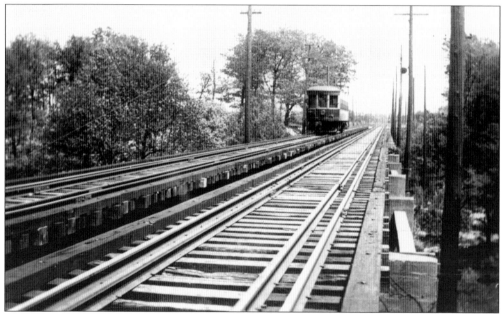

This is a wonderful photograph of the "high speed rails" going over the Huntington Trestle in Bay Village. The high-speed corridor ran from stop No. 1 in Rocky River to Arizona Avenue in Lorain. These lines were designed and scheduled for 60-mile-per-hour travel. The double tracks were installed by LSE in 1906, and the concrete trestles replaced the original wooden structure in 1925. An interesting note is that spikes were not installed at every tie.

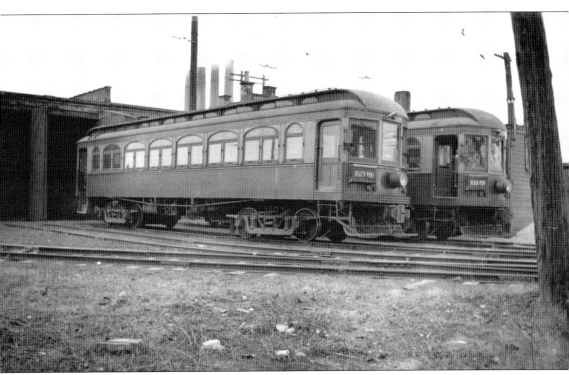

This photograph is of an original length Niles car at the Beach Park station in 1936. The big Niles cars were used as school buses in Avon Lake and Norwalk and also for other passenger runs.

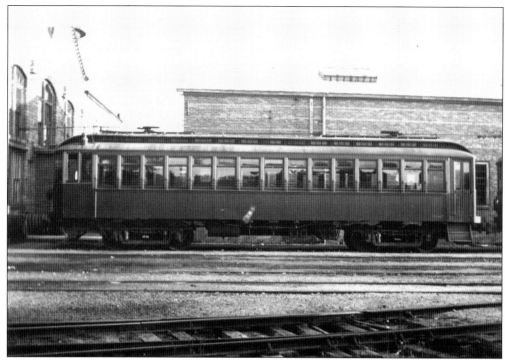

A double-ended B&S car sits outside the shop building in Sandusky. The double-ended cars were used in the last days as shuttle cars between Bellevue and Ceylon after the line was cut at Bellevue.

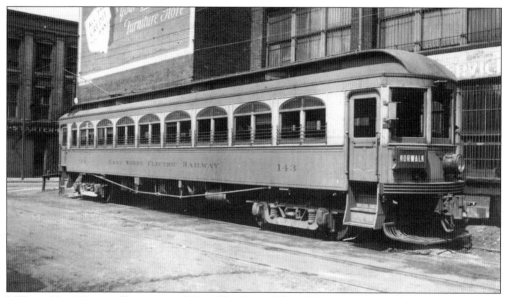

LSE car No. 143 is on "layover track" in Cleveland. This Niles car was rebuilt to carry the same number of passengers as the newer steel cars and was used to move rush-hour passengers to Lorain and also for school runs.

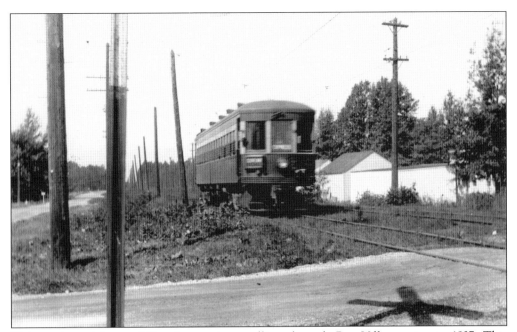

This eastbound Jewett 170-series car is travelling through Bay Village prior to 1937. This 60-foot-long car was built in 1917 or 1918 and was extremely fast, due to the power of four 140-horse motors.

The Cleveland Express is passing stop No. 15, Vineland Road in Bay Village, on September 7, 1936. This Jewett car is shown traveling on the high-speed line, probably reaching speeds of 60 miles per hour.

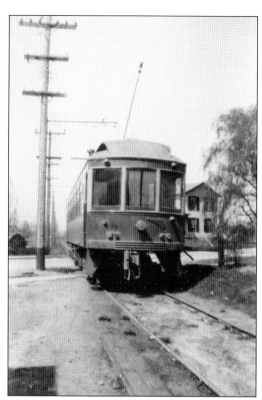

LSE car No. 159 is crossing West Main Street in Berlin Heights, northbound. This car was operating as the Fremont to Ceylon via Norwalk shuttle on the southern division.

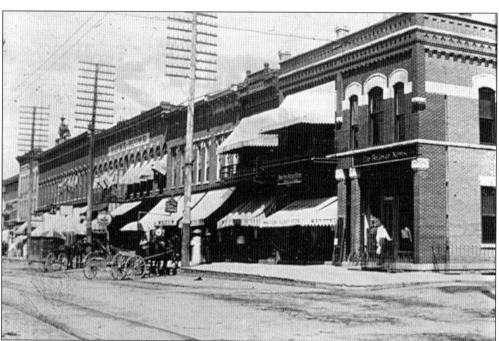

This early-1900s image is in Bellevue, looking west on Main Street at the Sandusky Avenue stop. This is a fine example of the type of town that gained access to the large cities on the LSE for commerce and shopping.

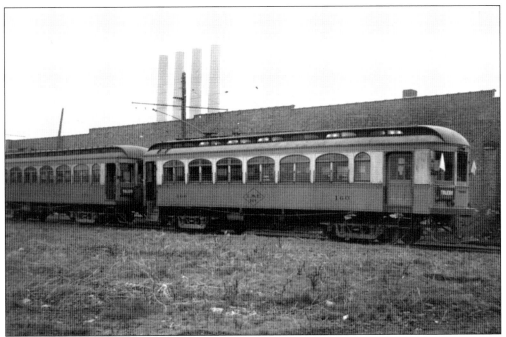

LSE cars No. 160 and No. 151 are shown idle behind the Beach Park station. The white flags show that they are on an extra run, or nonrevenue or irregular run. Flags were the appropriate way to designate an extra run during the day, with two white lights in the front of the unit being used at night.

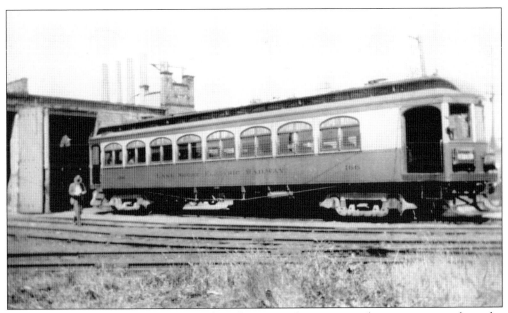

LSE car No. 166 faces east at the Beach Park station, showing its red stripe running along the bottom of the windows. The red stripe is the designation showing that this car and line belongs to the Everett-Moore Syndicate, of which LSE was a member.

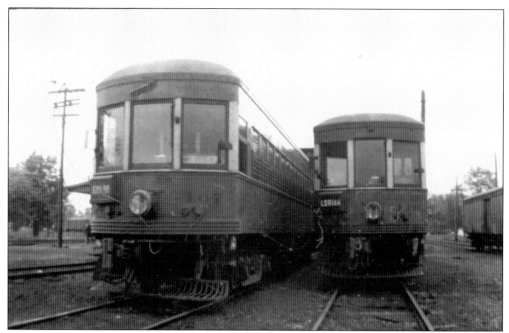

LSE cars No. 167 and No. 179 are seen here in 1938. Car No. 167 ran the Cleveland–Lorain local, as it had limited power and was seldom used on express runs. Note that unit No. 179 says, "Lorian," a factory error that remained for the life of the car. Car No. 167 operated with 100-horsepower motors and was configured to run with No. 165 and No. 166 on the Lima route.

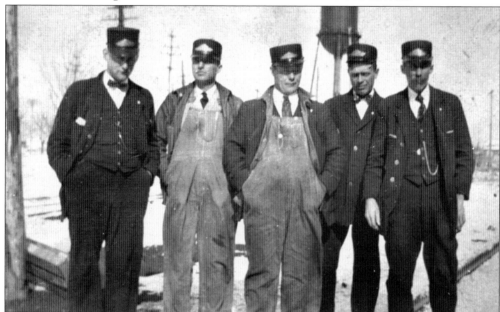

These three conductors and two motormen pose at the Beach Park station. This grouping would represent two and a half runs worth of operating crew, as every car had a motorman and a conductor. In the case of multicar trains, there would be a conductor for each car and only one motorman. This was due to the need to have someone collect fares on each car, but only one motorman to operate the unit and handle freight.

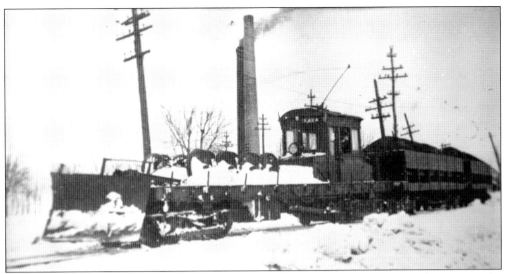

This original LSE work motor is pulling cinders from the Beach Park Power Plant. Note the wheel sets being used as weight, required to plow. The cinders were normally used for ballast and fill on the track line.

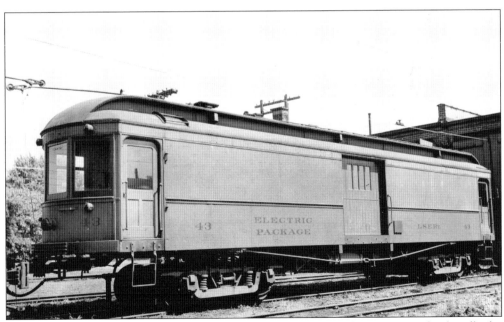

LSE car No. 43 started life as a Niles passenger car built in 1907 and was converted to handle the increasing freight business after World War I.

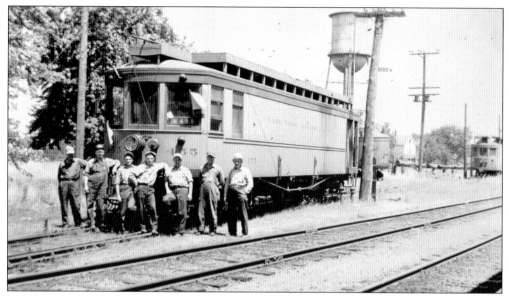

This line car and crew pose for a photograph at Beach Park. This is a "hot-running" line car, which means that it is used to install new overhead lines from the roll of overhead wire within the car. Note the spikes being worn by the pole climbers, who worked on hot lines from poles and the top of the wood line cars.

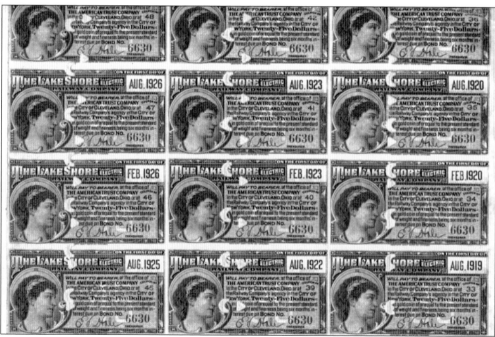

This is a full sheet of bond coupons, issued by the LSE. Unlike many of the debt holders, this lucky person obviously was able to redeem his investment, as indicated by the cancellation cutouts.

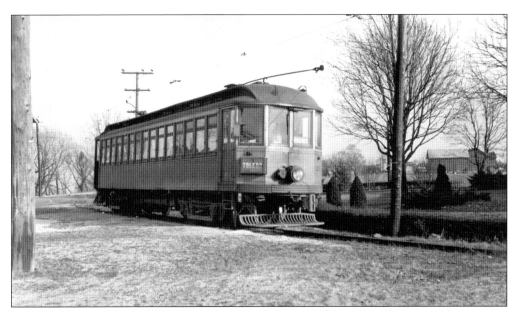

Car No. 23 started life as TF&N car No. 13 and then as LSE car No. 8000 until 1903. In this picture, the double-ended car is on the south leg of the wye at Ceylon Junction in Bellevue shuttle service.

Jan	Feb	Mar	Apr	May	June	July	Aug	Sept	Oct	Nov	Dec	1	15	30	45
1	2	3	4	5	6	7	8	9	10	11	12	2	15	30	45
13	14	15	16									3	15	30	45
17	18	19	20	21	22	23	24	25	26	27	28	29	30	31	

THE LAKE SHORE ELECTRIC RY. CO.

Good only on first car leaving transfer point punched, on date and before time punched, subject to Rules of the Company. NOT TRANSFERABLE. Passengers will examine their transfers as same will not be accepted unless properly punched

B 662839

	CAR to CAR	NORWALK		SANDUSKY		LORAIN		L. S. R.R.		A M	
1936 1937		West Main	East Main	City Cars	City Busses	Colorado	West Erie	East Erie	Oberlin Ave.	Broadway	P.M

This is a transfer used to allow one to transfer from LSE interurban cars to city streetcars operated by the company in Norwalk, Sandusky, and Lorain at no additional cost.

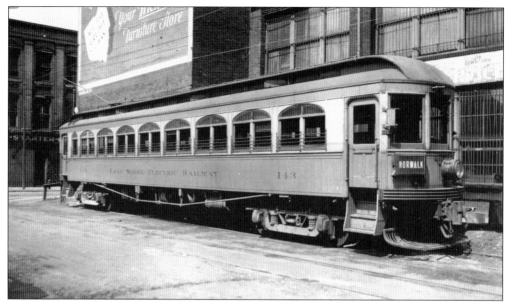

Car No. 143 is shown here on Eagle Avenue in Cleveland, which is located behind the Caxton Building. Cars would wait for the rush-hour passengers heading back to West Cleveland suburbs and Lorain.

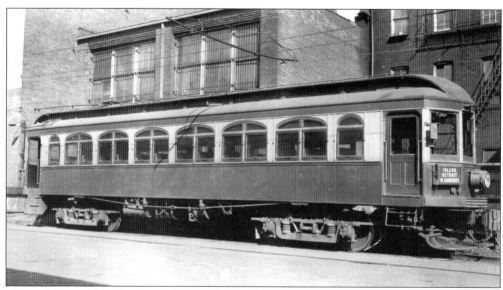

This is LSE car No. 158, shown here with a "Toledo, Detroit via Sandusky" sign, while waiting at Eagle Avenue in Cleveland.

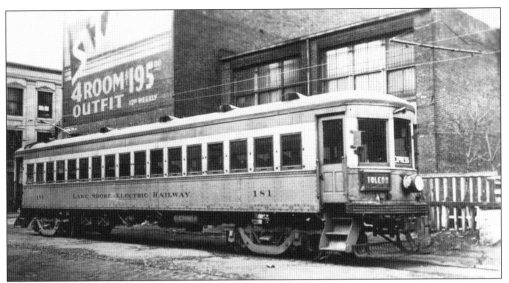

LSE car No. 181, shown here at Eagle Avenue in Cleveland, is interesting, as it clearly depicts an engineering problem that was common with Jewett manufactured cars. Note the water damage along the bottom of the car sides. This car is only 20 years old in this photograph and the rust is quite severe.

In 1919, Sherwood Anderson wrote *Winesburg, Ohio*, which is often equated with the more modern *Peyton Place*. Anderson's fiction is based on his home of Clyde, shown here at the Route 20 crossing, approaching the interurban station.

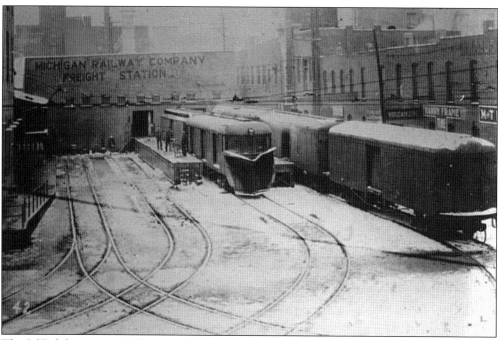

The LSE did not own Michigan operations but did interline with Michigan lines, particularly due to the relationships created through common ownership by the Everett-Moore Syndicate. This photograph shows an unusual snowplow configuration.

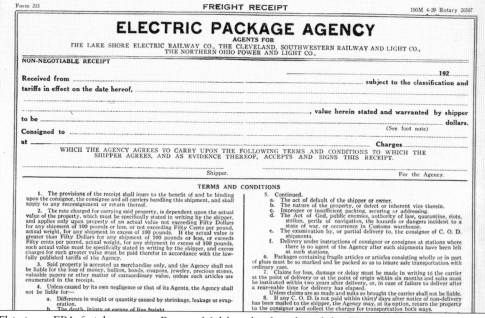

This is an EPA freight receipt. Barney Mahler, the founder of the EPA, was a very important innovator during the interurban heyday. He created, in partnership with many of the interurbans, a freight system that utilized the interline capabilities of the railways, including their stations and employees, to move packages and freight and most importantly account for and collect for this important service. His offices were located at Eagle Avenue in Cleveland.

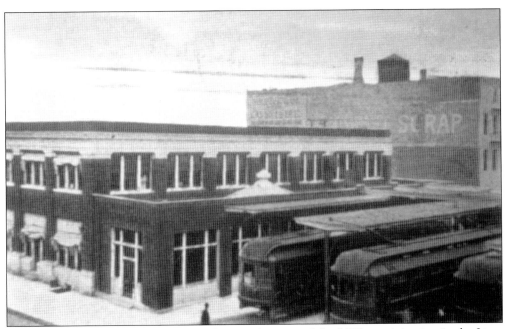

The is the interurban station at Lima. During the time of the LSE's participation in the Lima route, the LSE and/or Western Ohio cars would leave Cleveland, transfer to the TF&F at Fremont, and run over the tracks of the Western Ohio Railway to Lima. This service ended when the Western Ohio and the TF&F ceased operations on January 6, 1932.

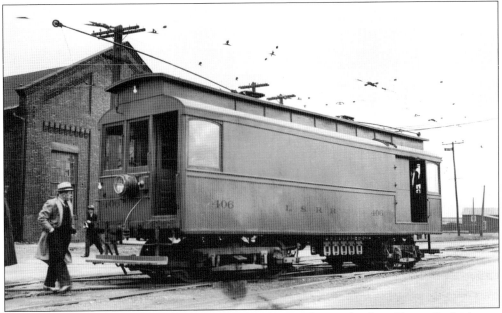

LSE car No. 406 is seen here at the Lorain carbarn. This is the "trouble car," which was originally built by American Car Company for Lorain-to-Cleveland passenger service and subsequently heavily rebuilt for use in working at wreck sites, towing, and general maintenance. This photograph was taken in 1938, during a fan trip.

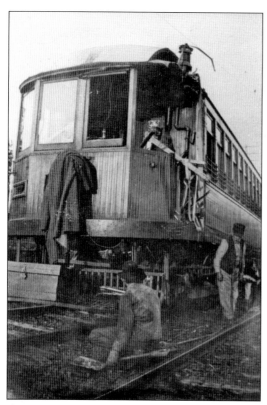

Depending on the source, this is a picture of LSE car No. 1, LSE car No. 11, or LSE car No. 13, seen at Mitiwanga siding after being clipped by passing LSE car No. 155. The B&S local was not clear of the switch before the limited car came by at 30 miles per hour. Workmen are repairing the car to be moved to the shop for repairs.

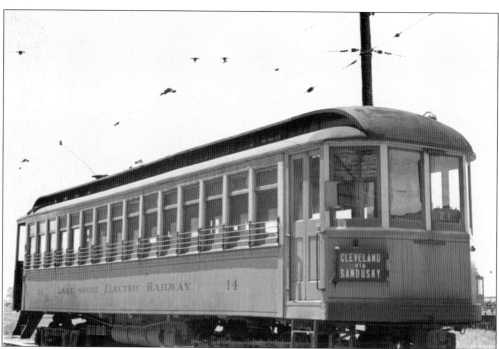

B&S car No. 14 sits at the Sandusky shop. After being superseded by three generations of LSE equipment, the B&S cars were still in local service at the end of the LSE.

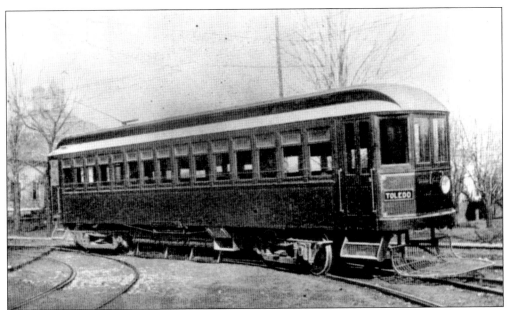

B&S car No. 18 is seen here with its multiple unit control boxes opened for a publicity shot for the *Electric Railway Journal*. Although equipped for multiple unit operation, they were never used as such. Note that this car does not have couplers for train operation.

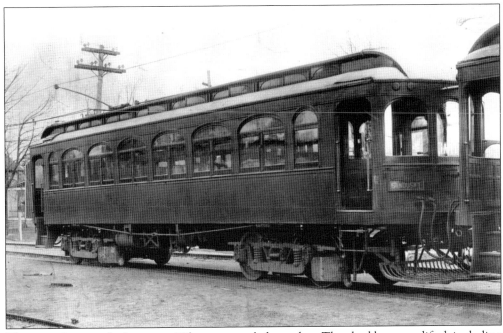

This rare photograph shows two Niles cars coupled together. They had been modified, including raising the end bumpers, Master Car Builder (MCB) radial couplers, and electrical connectors on the front and rear platforms. Due to the high speeds and roller-coaster construction of the line, the couplers had to be of solid heavy construction and required hi-knuckles to keep them together. Air brakes were connected by air hoses mounted on the couplers. LSE cars would interchange with Detroit United Railway (DUR) cars in trains to and from Detroit.

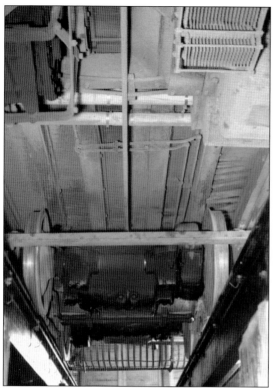

This photograph, taken from the maintenance pit, shows the bottom of LSE car No. 159 toward the front truck and the people catcher. On the left is the air compressor, and the right resistor grids for the control unit. The oily motor and gear case that surrounds each axle is in plain view. The rod running down the center is the brake rod to apply the brakes to the front truck.

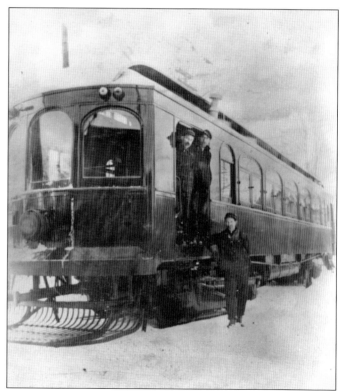

Part of the shop crew poses with LSE car No. 162, a Niles combine, in the snow. For some reason the car is running with trucks from a B&S car, showing the great flexibility used to keep the line in operation.

This photograph of LSE car No. 183 shows the bucket seats and new interior after the Sandusky shops rebuilt Michigan Electric Railway car No. 851 in 1930 to conform to LSE designs.

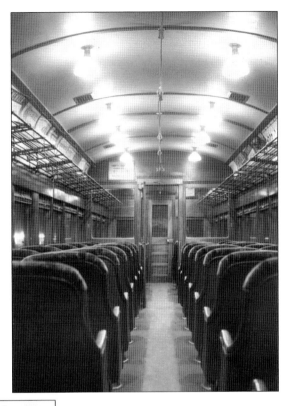

when all the concrete piers were ready, the old tracks and decks were removed one at a time, leaving one track open for operation except for short intervals. The steel girders were then set in place with an electric derrick and fastened down with flange plates, which fitted over bolts embedded in the concrete piers and were then welded to the girders.

The work, including design and construction, was done under the supervision of the writer. Construction

The Concrete Footings and Piers Were Constructed Without Disturbing Traffic. Work Was Done by the Maintenance of Way Forces of the Company

was so arranged as to give a minimum delay to traffic. It interfered in no way with other work on the line because it could be discontinued on short notice and resumed when circumstances permitted. The work was done by company forces without the addition of any extra men, and provided steady employment for the regular maintenance crew, when otherwise it might have been necessary to reduce forces with a corresponding loss in morale. The practice has proved so satisfactory that the concrete footings for a similar trestle to replace the remaining wooden trestle will be placed this fall and the rest of the construction done as part of the maintenance program which is planned for the coming year.

Cash Handled by Local Express Company

IN HANDLING money between carhouses and downtown banks, the Chicago Surface Lines has abandoned the use of cars operated over its lines and has made a contract with a local express company to do this hauling. Protection is furnished by bond and insurance. Money is collected by the express company from sixteen carhouses and is delivered directly to three downtown banks.

Remodeled Cars in Trenton

BY H. E. KROUSE
Superintendent of Equipment Trenton & Mercer County Traction Corporation, Trenton, N. J.

SINCE the first of this year the Trenton & Mercer County Traction Corporation, Trenton, N. J., has operated its cars exclusively with one man. Of the cars operated 50 were of a large double-truck type with comparatively small platforms, narrow aisles and with no special equipment to facilitate operation in emergencies or even under normal conditions. This lack of equipment caused criticism from the traveling public, affected the keeping of schedules and aggravated a serious traffic situation which, due to Trenton's geographical layout and rapid growth, was assuming serious proportions.

With the proper equipment for front entrance with rear exit on the older type large cars, operated by one man, two things were accomplished. First, the stopping time at points of heavy passenger interchange was shortened by eliminating aisle friction and providing for loading and unloading simultaneously. Second, due to a rear exit, a more uniform distribution of the passenger load, particularly during the peak hours, was obtained. National Pneumatic Company's automatic treadle device for control and operation of the rear doors was chosen for experiment on two cars.

To utilize this equipment and secure a greater factor of safety in operation the cars were repiped, using Safety Car Devices safety equipment with the exception of the dead man control and foot valve. To compensate for this a conductor's valve was installed with a pull cord running the entire length of the car body. This was marked plainly as to its emergency use, for the benefit of the passengers.

All the desired results were obtained and operation

Remodeled Car Fitted with Automatic Treadle for One-Man Operation in Trenton, N. J.

was provided equivalent to the highly satisfactory but expensive form of two-man operation used by the company on Birney cars. In addition the advantage of safer operation was obtained by eliminating the human tendency to err at critical moments and in relieving the operator of his work of operation and responsibilities.

Equipment was ordered for 50 cars and it is now being installed as rapidly as possible. The illustration shows an old type of former interurban car re-equipped with these devices and now being operated by one man to try out the new equipment in congested city service.

This article from a fan magazine that published excerpts from the *Electric Railway Journal* details how the LSE replaced the wooden trestles at Cahoon Road and Huntington Park in Bay Village with the steel bridge and concrete piers that are still there today.

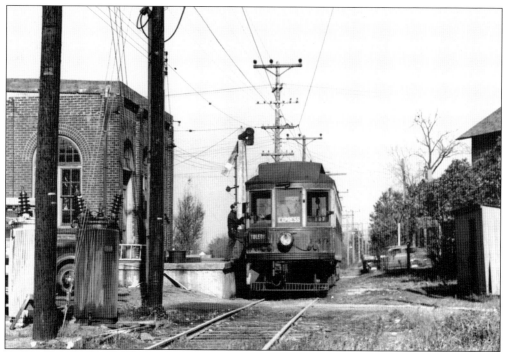

LSE car No. 149 is stopped at the Berlin Heights station/substation to load some package freight on its way west to Norwalk and beyond on the southern division. This photograph was taken on October 9, 1935.

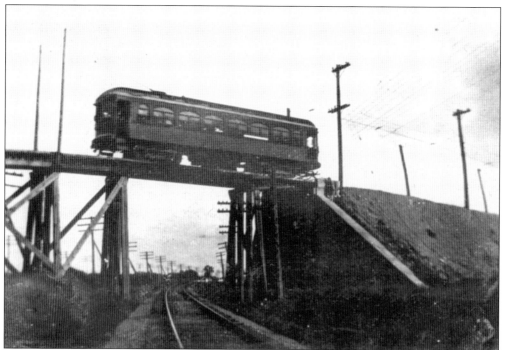

A Niles car eastbound crosses the original trestle/bridge crossing the Lake Shore and Michigan Southern Railroad (LS&MS) and WLE on the east side of Bellevue.

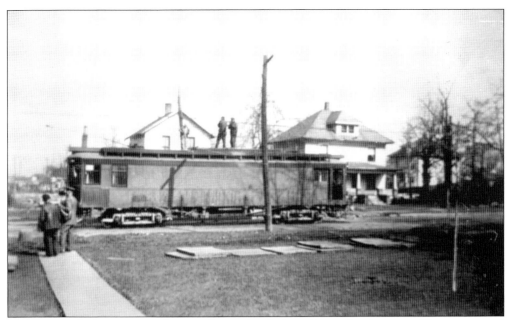

The crew on the line car is working on the overhead where the road underpass will be constructed on the east side of Bellevue. The line was rigged with single-span catenaries while the underpass was being dug on each side of the track. Finally it got to the point where the track had to be removed to finish the job and the southern division was cut in half forever.

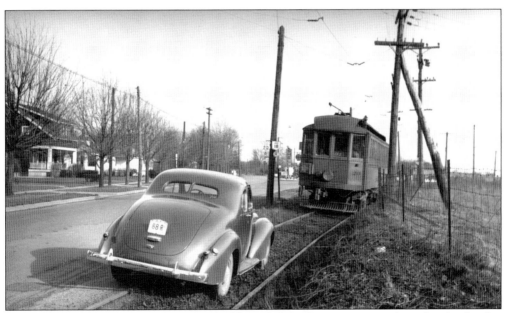

Once the track was cut at Bellevue, double-ended B&S cars were used to shuttle the few passengers and package freight between Ceylon Junction and the east side of Bellevue where Routes 20 and 113 meet. The automobile seen here is the local taxi hired to ferry passengers and packages to the station on the west side of town.

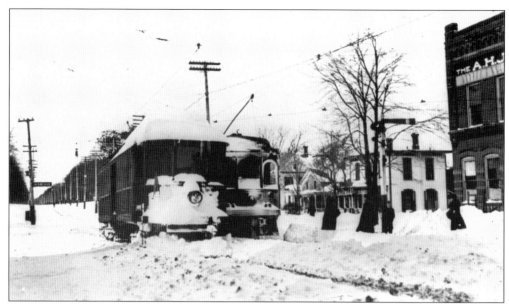

This very rare photograph shows LSE car No. 41 and a Niles car at the station on a snowy afternoon around 1930. LSE car No. 41 was an original L&C package express car built by Brill in 1898 that was still in the yards when the line was scrapped in 1939.

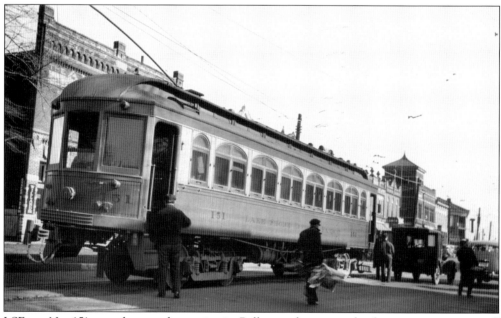

LSE car No. 151, seen here at the station in Bellevue, shows a pack of newspapers coming off the rear platform while the motorman assists the EPA driver and truck at the front. After the line was cut at Bellevue, the car would turn on the station wye and head back to Fremont while passengers were transferred by taxi to a car waiting on the east side of town.

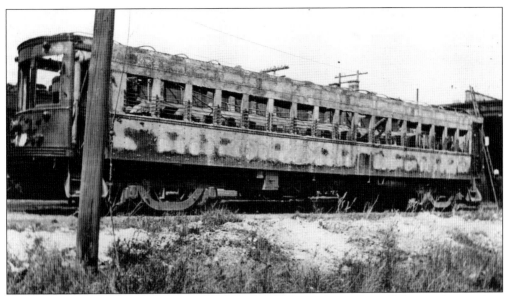

This photograph shows LSE car No. 175 at Beach Park burned out after colliding with a gasoline truck in 1929.

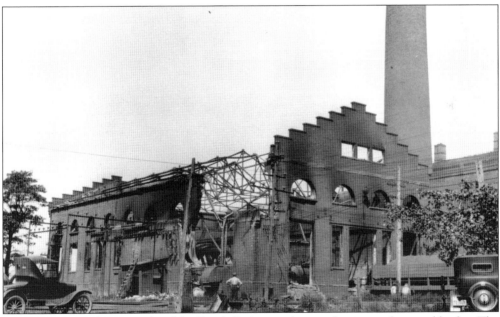

This view shows the west side of the Beach Park powerhouse after it was destroyed by fire. The fire apparently started when an oil-filled transformer exploded in the basement directly below where the building wall has collapsed. As a result of this fire, LSE moved all interior transformers to outside locations.

Bill Lang poses for the photographer shortly after his dramatic rescue of a child that won him a Carnegie lifesaving medal and resulted in a back injury that dogged him for the rest of his life.

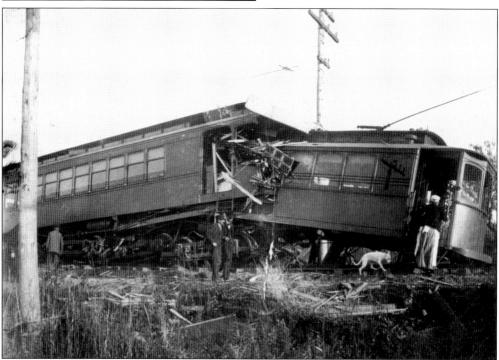

This is the LSE car No. 68 seen after the Wells Road crash. When the LSE car No. 40, an original L&C car, was scrapped, LSE car No. 68 was rebuilt in the company shops.

CAR CARD

F. W. COEN, Receiver

THE LAKE SHORE ELECTRIC RAILWAY CO.

Form 209—10M—3-37—C

Car No._____ Initials_____ Date_____

From____ CLEVELAND _____

To_____

Via_____

Contents_____

Consignee_____

This is an LSE car card. This document acted as the manifest for freight cars and was present on every loaded car.

This unused LSE cash fare receipt clearly shows how accurately and meticulously fares were accounted for by the LSE.

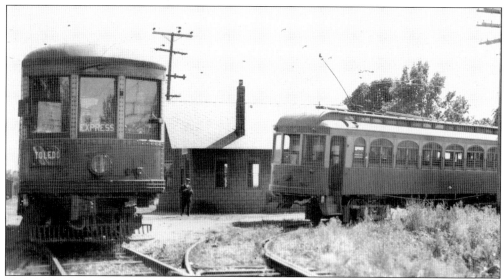

Seen here at Ceylon Junction, this LSE car No. 182 heads west to Sandusky while LSE car No. 157 prepares to head to Fremont via Norwalk. Lake erosion has taken out the bank back to the left rail.

On December 6, 1927, an LSE freight motor hauling a Dayton and Western Traction Company freight trailer moves along Ontario Avenue, heading for Public Square and the high-level bridge to head west. The picture was taken from the central viaduct, which was closed for several years during the building of the Cleveland union terminal. Freight trains for the LSE and Cleveland Southwestern Traction Company (CSW) normally traveled west over the central viaduct to keep them off Public Square. During this period all freight and passenger service went through Public Square and the high-level bridge.

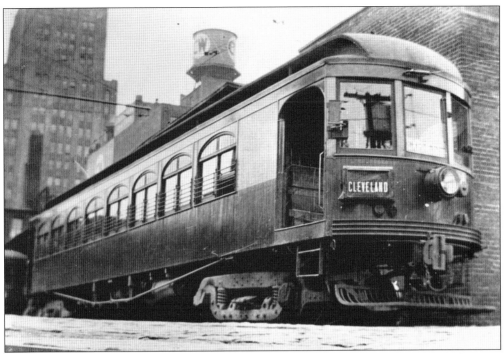

LSE car No. 166 sits at the EPA on Eagle Avenue in downtown Cleveland with the baggage compartment loaded with boxes of fresh-caught iced fish from Kishman Fish in either Vermilion or Huron.

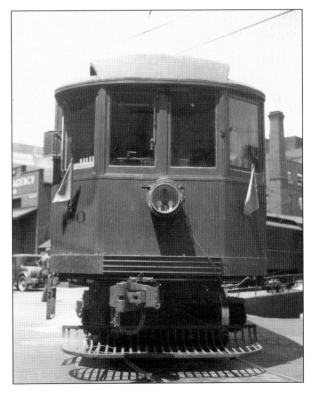

B&S freight motor car No. 30 sits at the EPA in Cleveland, flagged for an extra daylight freight move.

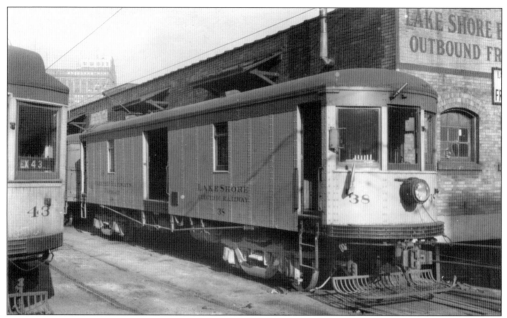

B&S freight motor car No. 38 heads up a train at the EPA in Cleveland. The color scheme is an orange body, red letter board, gray trucks, and black or gray roof.

A busy less-than-carload freight business is being conducted at the EPA terminal on Eagle Avenue in Cleveland. Trucks are bringing goods in, and freight motors and trailers are being filled.

LSE car No. 149 is at the Cleveland interurban station handled by motorman Chris Snyder and conductor Whitey Rook, ready to head west to Toledo. Judging from the shadows, this picture was taken shortly after 1925 when train No. 213 left Cleveland at 1:00 p.m. instead of 3:00 p.m. as it did on later schedules.

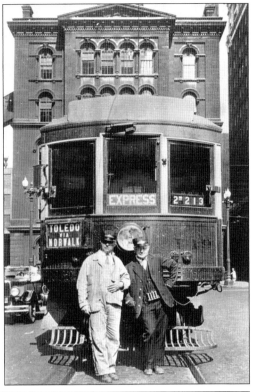

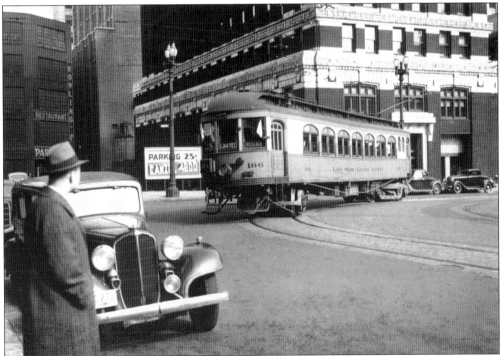

There are 60 feet of wooden interurban creaks and groans as LSE car No. 166 makes the final turn into the track in front of the Cleveland interurban station at 25 Public Square.

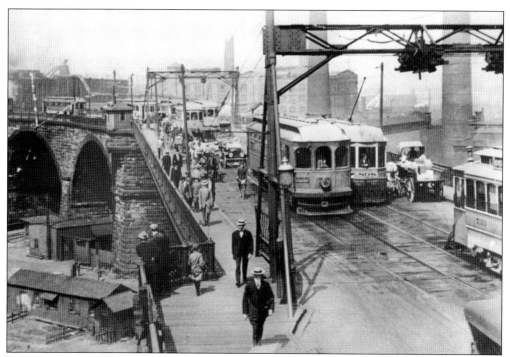

The scene is the Superior Viaduct in 1914 as streetcars and interurban cars crawl across the long swing span. Every time a boat went up or down the Cuyahoga River the bridge opened and traffic stopped. Eventually the Detroit Superior high-level bridge eliminated this bottleneck.

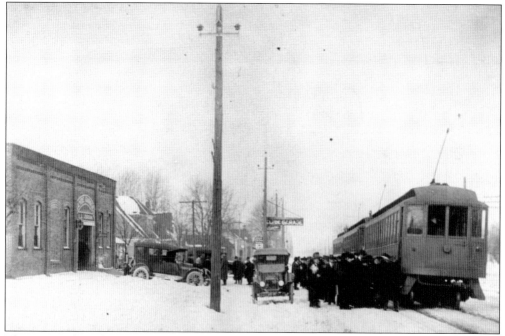

This scene takes place in Clyde on Route 20 in front of the Clyde garage, which is right across from the Clyde station. A charter run of two B&S cars and one Brill car is taking a theater party to Toledo for the day.

A young conductor ponders the future in between runs standing on the people catcher mounted on the front of LSE car No. 23.

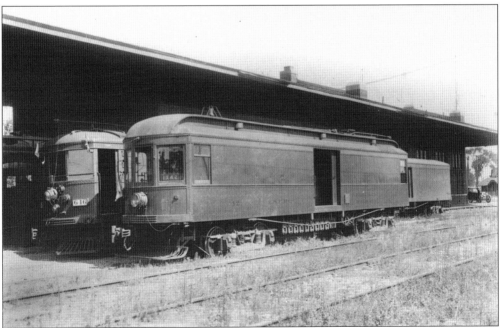

LSE car No. 42 and Cincinnati and Lake Erie (C&LE) car No. 616 sit at the DUR freight terminal outside Detroit, waiting to be loaded.

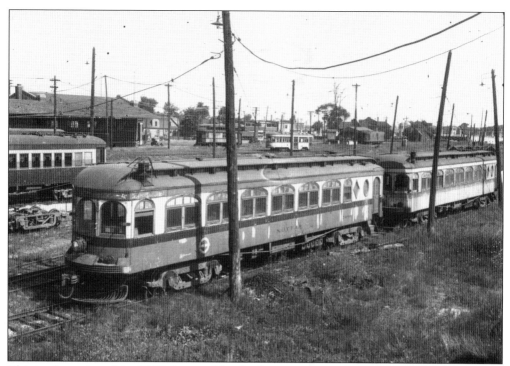

This is a long view of the DUR shop and freight depot on the outskirts of Detroit. Out-of-service wooden DUR cars and freight motor, a Detroit streetcar, and the back end of LSE car No. 167 or LSE car No. 168 can be seen.

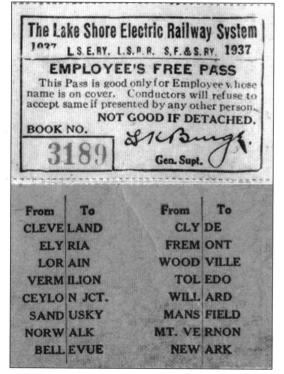

The Lake Shore Electric Railway System
1027 L.S.E.RY. L.S.R.R. S.F.&S.RY. 1937

EMPLOYEE'S FREE PASS
This Pass is good only for Employee whose name is on cover. Conductors will refuse to accept same if presented by any other person.
NOT GOOD IF DETACHED.

BOOK NO. 3189 *L. K. Burgh.*
Gen. Supt.

From	To	From	To
CLEVE	LAND	CLY	DE
ELY	RIA	FREM	ONT
LOR	AIN	WOOD	VILLE
VERM	ILION	TOL	EDO
CEYLO	N JCT.	WILL	ARD
SAND	USKY	MANS	FIELD
NORW	ALK	MT. VE	RNON
BELL	EVUE	NEW	ARK

Free passes were issued to employees, families, dignitaries, and officials from other rail lines. This 1937 pass is just one from the book of passes that would have been issued to employees. This is how employees got to work without having to use an automobile.

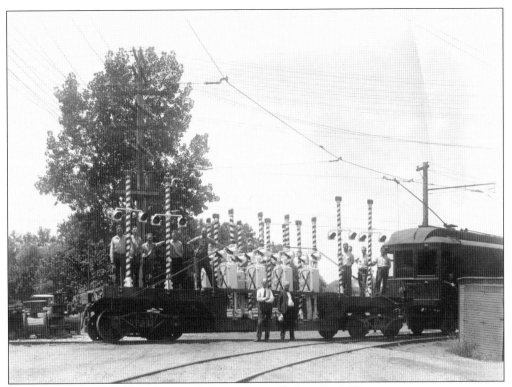

Safety first is displayed here as new flashers are installed on the LSE.

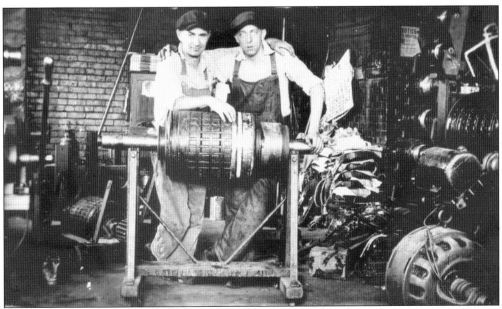

These friends to the end are seen here at the armature rebuilding room in the Fremont shop.

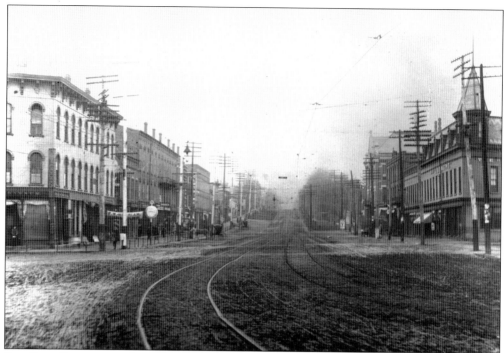

East State Street is seen here in Fremont as a dirt road and interurban heaven.

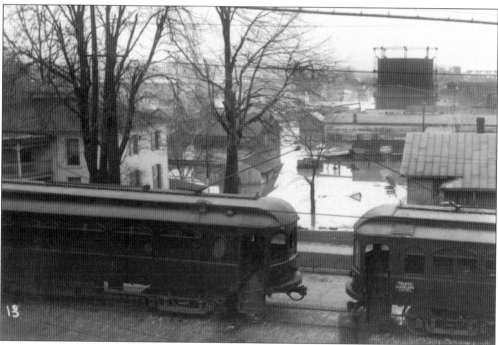

High water at Fremont caused passengers to transfer to a westbound Toledo car. This must have been awkward because the only place for the car to turn around was at Gibsonburg Junction, some 30 miles to the west.

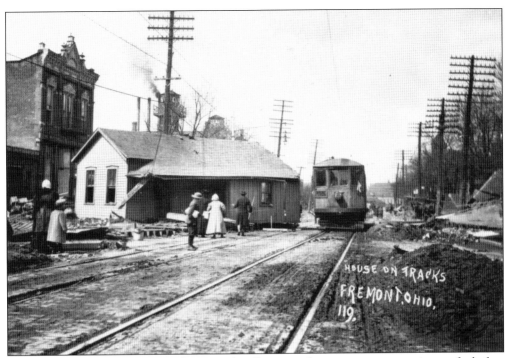

After the waters of the 1913 flood retreated in Fremont, there were some surprises to fix before normal operation could begin.

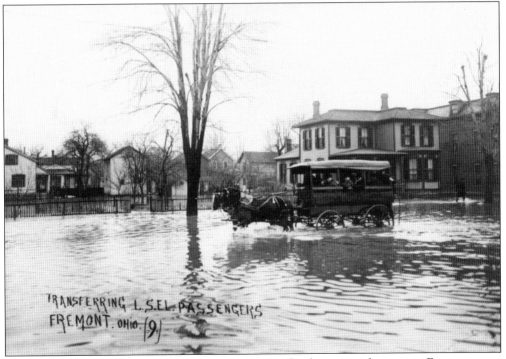

This is how the LSE passengers got through the floodwater in downtown Fremont prior to 1912.

The freight house in Fremont handled a large volume of business. It was located on South Fifth Street, out of the flood plain, with a shop building behind it. The powerhouse stack is in the background.

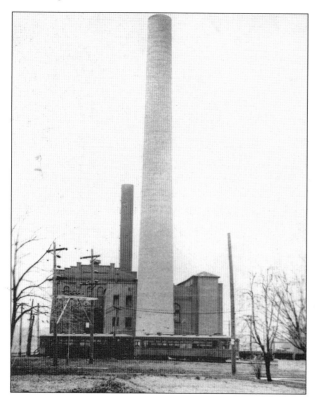

Fremont powerhouse has lightweight cars from the TF&F parked in back.

Crews are repairing and reballasting track work in front of the Fremont shop building.

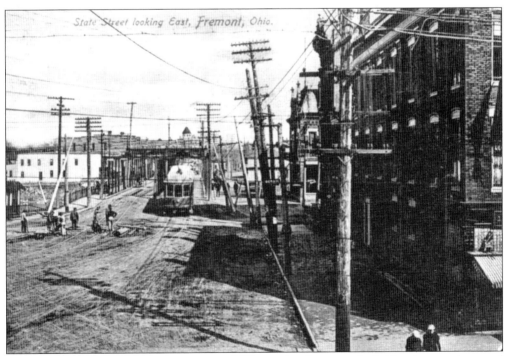

On State Street in Fremont looking east, an LSE car is heading over the bridge that was destroyed in the 1913 flood while a track gang does some minor repairs in the street.

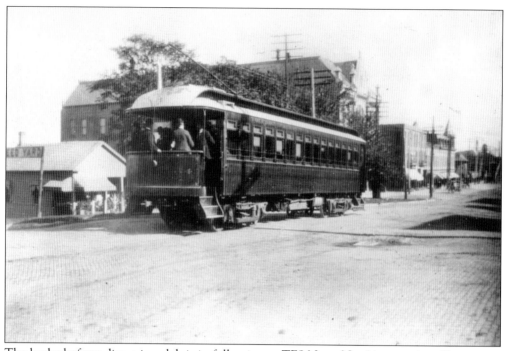

The back platform discussion club is in full swing as TF&N car No. 14 comes into Fremont in the pre-LSE days.

For the majority of its life, the LSE rented station space in Fremont from the WLE at its station conveniently located in the center of Fremont at the river.

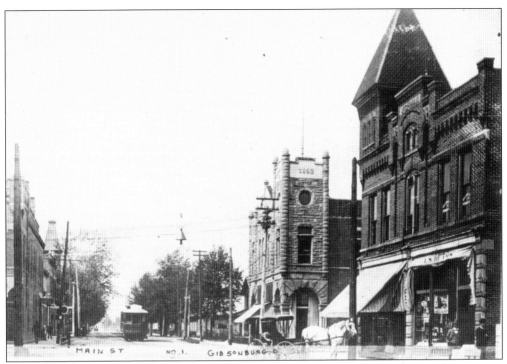

This photograph of an LSE shuttle car was taken in downtown Gibsonburg. This car was originally the SM&N double-deck Pullman Sessions car that was converted to a single-deck closed car sometime before 1900.

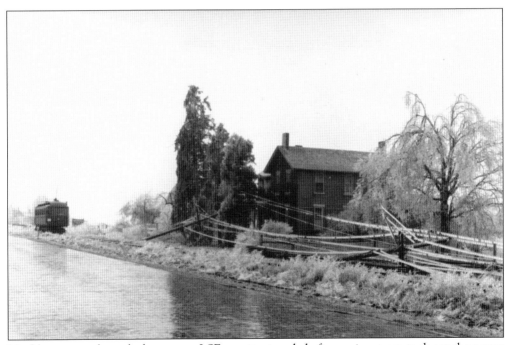

Unable to coast through the gap, an LSE car sits stranded after an ice storm took out the power lines in the winter of 1937–1938.

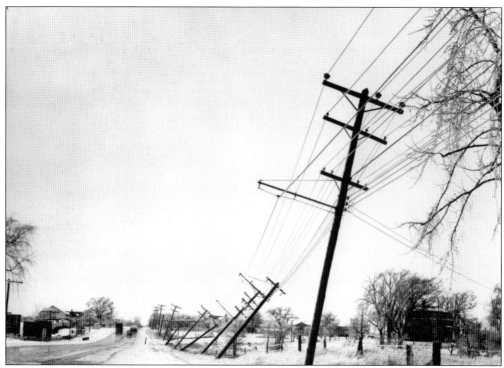

A bad ice storm in the winter of 1937–1938 knocked down a lot of poles and overhead wires. The results of the storm are seen in this scene, east of Fremont.

This is a photograph of the LSE double track line crossing Colorado Avenue on the east side of Lorain, looking east.

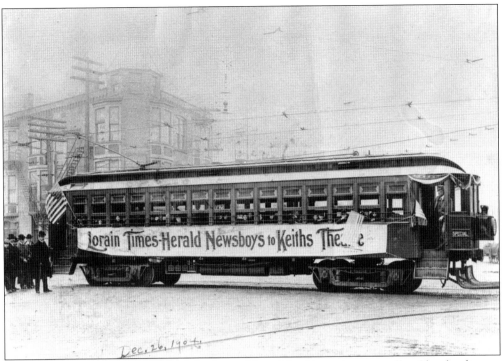

The date is December 26, 1904, and the *Lorain Times Herald* newsboys are off to Cleveland to see a show at Keith's Theatre. The location is the interurban station on West Erie Avenue in Lorain, and the car is a B&S in its original configuration with steps in the left front end. An oil-burning headlight completes the picture.

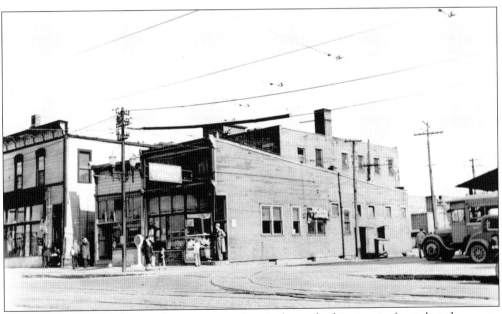

Not only did the third interurban station in Lorain have the big sign in front, but the penny scale is a dead giveaway. Many interurban stations had such a scale that the railroad got a share from but the customers got their weight and fortune for the day.

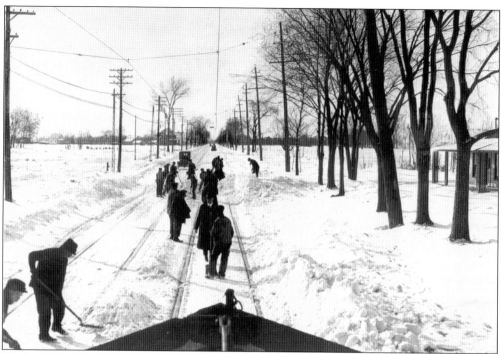

Work motor car No. 404 from Beach Park comes the rescue plowing snow on West Erie Avenue in Lorain. The cleanup crew follows with shovels to clean out the flange ways. Part of the franchise to run over city streets included plowing the snow and maintaining the pavement in between and around the rails.

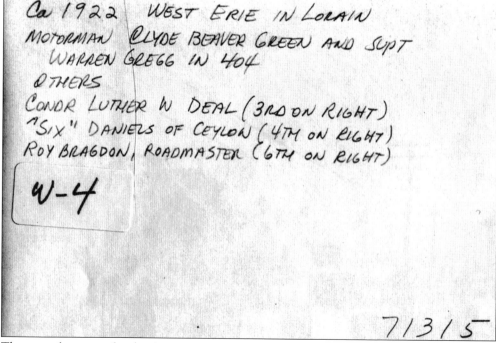

Ca 1922 WEST ERIE IN LORAIN
MOTORMAN CLYDE BEAVER GREEN AND SUPT
 WARREN GREGG IN 404
OTHERS
CONDR LUTHER W DEAL (3RD ON RIGHT)
"SIX" DANIELS OF CEYLON (4TH ON RIGHT)
ROY BRAGDON, ROADMASTER (6TH ON RIGHT)

W-4

71315

These are the names for clearing snow.

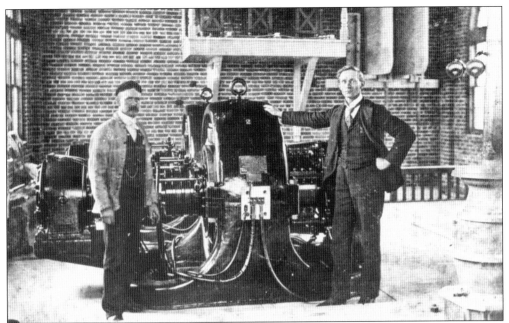

This is a picture of the interior of the substation portion of the Monroeville station/substation. Standing in front of the rotary convertors are station operator Irv Williams on the left and LSE superintendant Milt Trueman on the right. In the background are the lightning arrestors and line switches for the high-tension alternating current that was converted to 600 volts direct current by the two units to power the overhead wire.

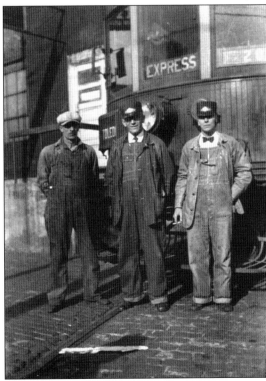

The scene is the Toledo freight house behind the station. In front of LSE car No. 160 is motorman Bill Lang flanked by a yard worker and another LSE motorman.

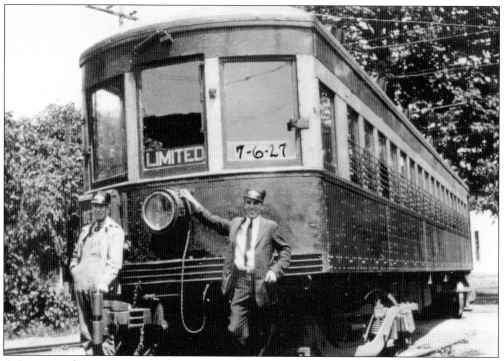

A Jewett steel car is running as motorman Chris Snyder and a smiling conductor Burns pose with a Detroit Limited car on July 6, 1927. The future looks bright.

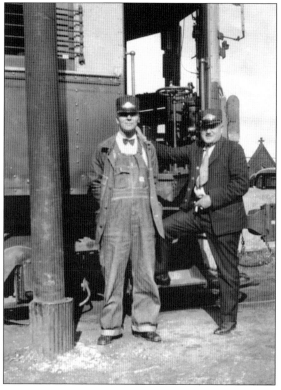

With the Eagle Avenue Cemetery in the background, a motorman and a conductor take a break, waiting for their next run.

This happy crew of LSE car No. 149 is at the end of a school "bus" run in Avon.

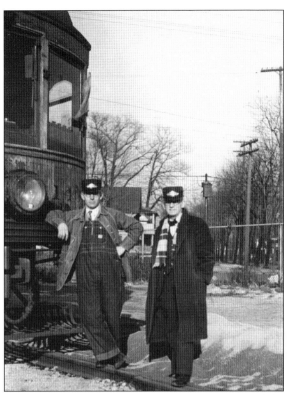

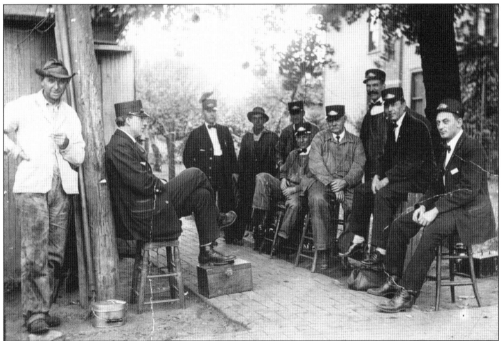

LSE crews enjoy a respite between runs in the shade. Among the tools of the trade are the personal motorman's stool, the conductor's valise and box containing change, tickets with paperwork, and at least one tin lunch pail.

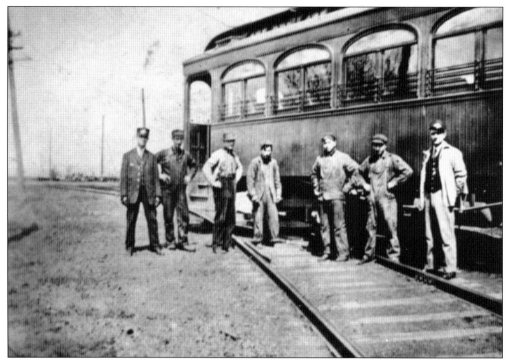

In another example of flexibility, an LSE Niles car on the Sandusky shop yard lead is seen, the odd thing being that the car is running on trucks from a Brill 60-series car. The motorman and conductor are posed with shop personnel.

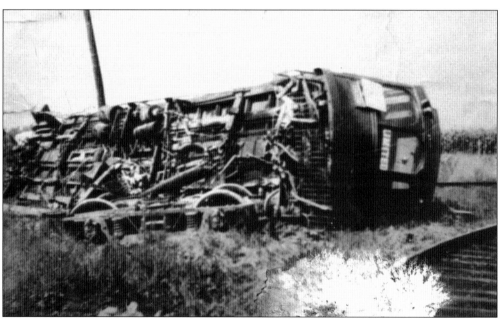

Lying in a field on its side is the wreck of a Niles car. It has completed its last trip; verdict, too fast around a curve.

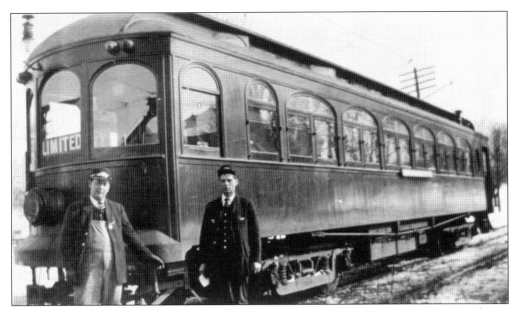

This is a picture of a Niles car in its original configuration with the motorman and conductor posed for a snapshot.

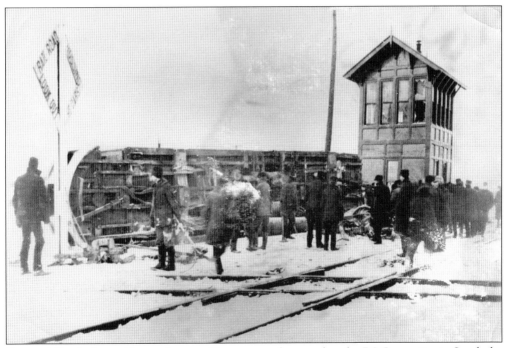

Original Sandusky and Interurban car *Gamma* was destroyed at the B&O crossing in Sandusky by a passing train. This wreck caused manually operated derails to be installed, requiring a complete stop in both directions. Instead of car numbers, the Sandusky and Interurban assigned Greek letters. *Alpha*, *Beta*, and *Gamma* were passenger cars, and *Delta* was a freight car.

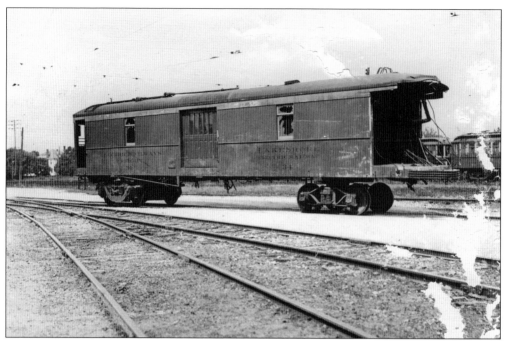

This photograph of LSE car No. 34 freight motor was taken in Sandusky after it suffered a head-on collision with a passenger car while running on the C&LE in southern Ohio. The car was never rebuilt.

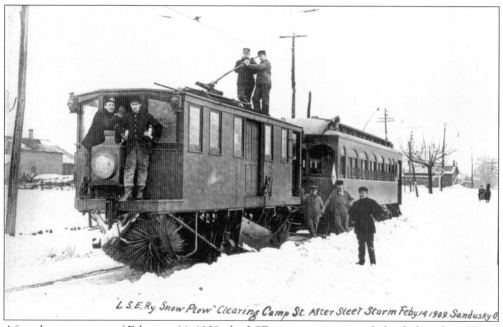

L.S.E. Ry. Snow Plow" Clearing Camp St. After Sleet Storm Feby.14 1909. Sandusky O

After the snowstorm of February 14, 1909, the LSE sent out a sweeper helped along by LSE car No. 70 to clean the streets in Sandusky. Notice the two men on the roof forcing the trolley pole against the overhead wire to ensure good contact—it is live, carrying 600 volts of direct current to the car motors.

LSE car No. 39 is a freight motor, seeing heavy duty on the LSE. The LSE was one of the exceptions in the interurban industry as freight was important at all stages of its operation. This car was built in total at the Sandusky shop.

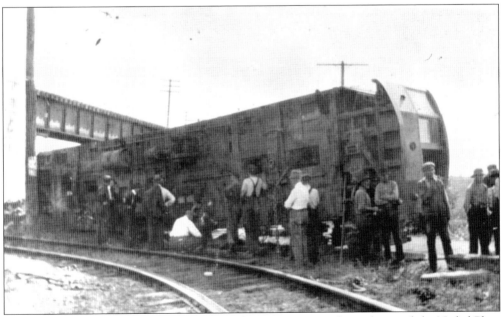

This photograph shows stop No. 109 and the hairpin curves under and around the Nickel Plate Railroad west of Lorain. This location named "undergrade" was the scene of several wrecks due to ice or loss of brakes on the steel downgrades of the approaches. Here B&S car No. 7 is seen on its side, ready to be turned up and put back on the trucks. The car was repaired and put back into service.

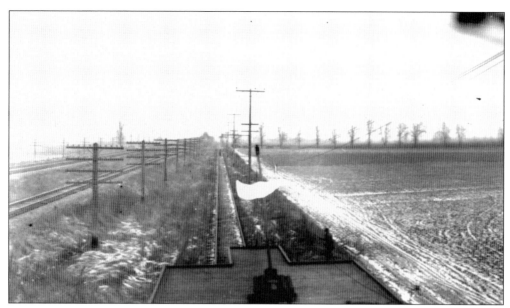

This picture was taken from the roof of line car 455 looking west. This is the LSE west of Norwalk four miles from Bellevue near McCuray's Creek on a cold windswept winter day.

Huron station agent George Windau looks askance at the seemingly grim Wells-Fargo express representative W. J. MacGreery as two wagonloads of freshly caught iced fish await shipment.

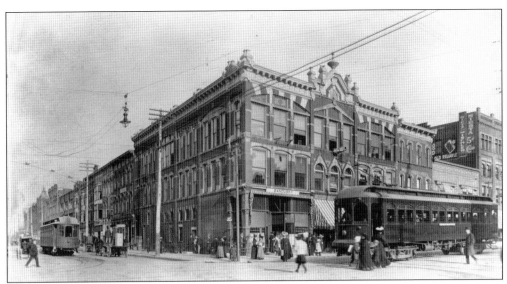

The second interurban station in Sandusky was located on Columbus Avenue, a block or two south of the third station. An almost brand-new LSE car No. 151 is loading to head out to Cleveland while LSE car No. 54, a former Lorain–Elyria car No. 54, is pressed into city service.

This is a 1908 LSE time table, with the front cover that appears to be a popular cover for the LSE. It is interesting to view the fares in place at the time and also the corporate and operating hierarchy.

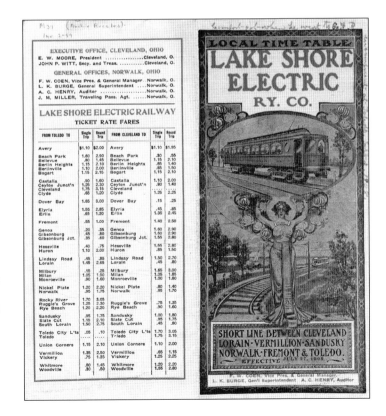

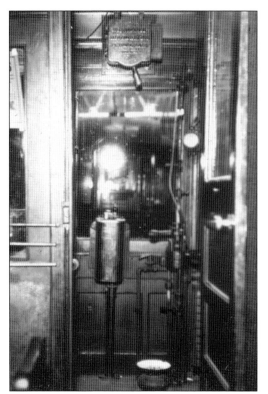

The interior of LSE car No. 150, a Niles car, documents the motorman's spittoon, the main direct current breaker above, and sander valve to the lower right. Every interurban had a sandbox, to apply sand to the front wheels for traction. Compressed air controlled by the sander valve blew the sand under the wheels to minimize slipping.

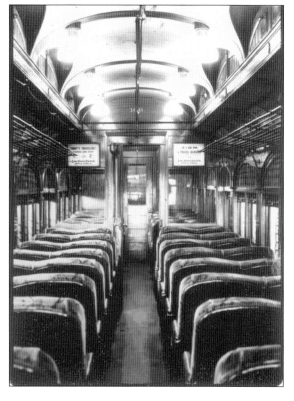

This photograph of LSE car No. 166's interior was taken after 1925. It shows upholstered bucket seats and six pairs of leather buckets seats in the smoking compartment. The ceilings of car No. 165 and car No. 166 were known as full empire ceilings due to the fancy curved panels.

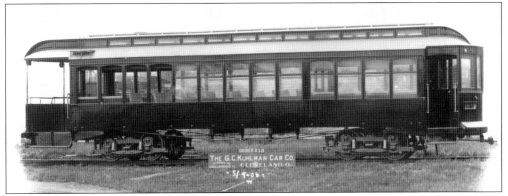

Seen here is a Kuhlman Car Company builders photograph of a brand-new Lorain–Elyria interurban car. Note the extra-large rear platform to accommodate smokers and hackers. The body is sitting on shop trucks and does not have the electrical apparatus installed.

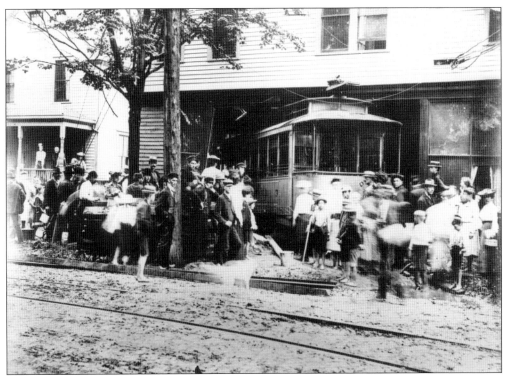

In 40 years of operations, only one car missed the curve from the private right-of-way onto Lodi Street in Elyria. Unfortunately, the car coasted into Koplin's drugstore, at which point the floor collapsed, sending the trucks into the basement. Minor scrapes and injuries were incurred, and a great deal of effort was required to pull the wrecked body out and jack the trucks up out of the basement.

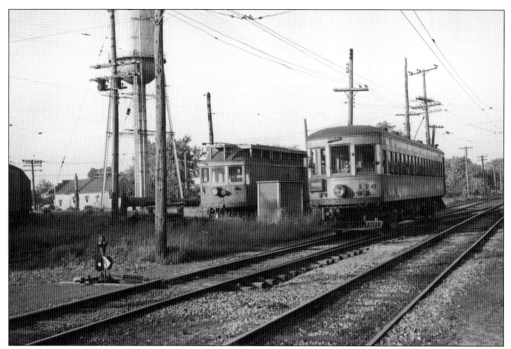

The Beach Park line car watches as LSE car No. 176, the Toledo Express, sails by Beach Park without stopping. If the stop signal was not set and no one was getting off they would roll on by. Lake Road is to the left of photograph, and Moore Road is seen in the background.

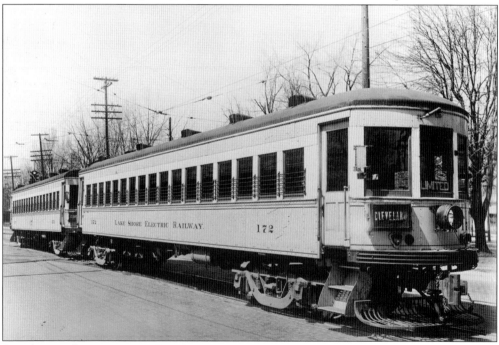

Seen here with new paint on East State Street in Fremont are LSE car No. 172 and car No. 173 shimmering in the sun. Clearly visible in this company photograph is the new band of yellow around the windows and the red stripe down the belt rail.

Three

LAKE ERIE TOWNS
AND VACATIONLAND

Boarding a local car in Cleveland and commencing travel to Toledo, a stop would be made in Rocky River, a pleasant farm area known for truck and fruit farming.

Stops in Bay Village were popular for business commuters and also allowed stops at Cahoon Road and Long Beach (also known as Huntington Beach) for bathers. The train would go on to Avon (after 1917, this area became Avon Lake, as citizens voted the town splitting Avon into Avon Lake to the north and Avon to the south), where cottages sprang up near the railway and north to Lake Erie. Numerous beaches were available to day visitors and to the cottage owners, as some of the north–south street deeds gave beach access ownership to all the lot owners. Stops at Avon–Dover Beach and many of the other Avon stops allowed beach access to the urban dwellers in Cleveland. To enhance rider census, the LSE built the dance hall and park at Beach Park in Avon Lake, just east of the power plant. Going on to Sheffield Lake and then Lorain, where industry, including Tom L. Johnson's steel mill (becoming U.S. Steel), American Ship Building, and Thew Shovel to name a few, relied on the speed and frequency of the LSE.

The towns, villages, and resorts between Lorain and Sandusky were primarily thought of as vacationland. This is understandable, as virtually every stop was lake accessible and normally a beach and/or park was available to day and holiday passengers. The most prominent park was (and remains) Cedar Point, just outside Sandusky, and was served by the LSE in combination with Cedar Point's steam ferry. The rail traveler would interchange in Sandusky to the G. A. Boeckling Steamship to cross Sandusky Bay to Cedar Point.

From Sandusky to Toledo, the stops were primarily rural and agrarian, with the exceptions of Fremont and Norwalk. The other towns of significance, served by the LSE, were handled by non-main-line service or interline services.

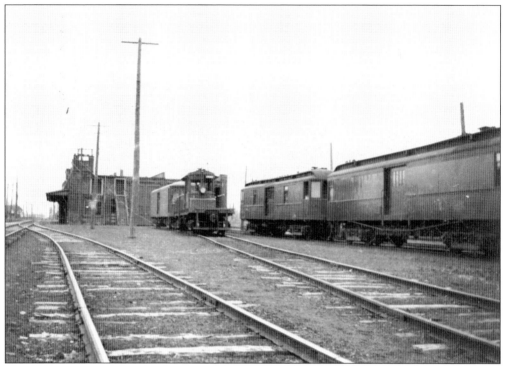

The 1930s were good days for the interurbans. This photograph shows the Beach Park station.

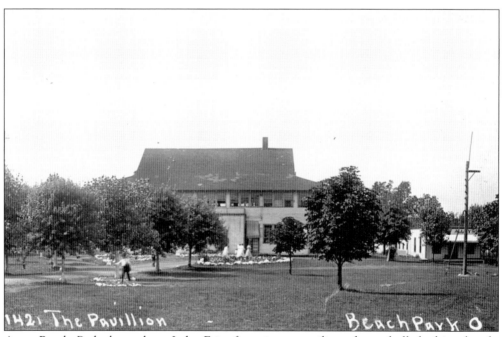

Avon Beach Park, located on Lake Erie, featuring a pavilion, dance hall, bathing beach, and picnic/camping grounds, was adjacent to the power plant (currently Cleveland Electric Illuminating Company property). The LSE advertised a midnight "last car" from Avon Beach Park, allowing the dance hall to operate into the night.

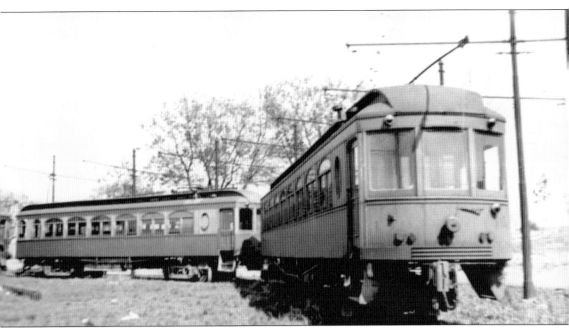

LSE cars are lined up at the Ninth Street Pier in Cleveland, awaiting the large number of passengers that were handled by the line during the Great Lakes Exposition of 1936–1937. How times have changed! During the midst of the Great Depression, Cleveland, the fifth-largest city in America, hosted this wonderful exposition that drew over seven million attendants in its two years of operation. The exposition site includes what is now Brown's Stadium, Great Lakes Science Center, and Burke Lakefront Airport.

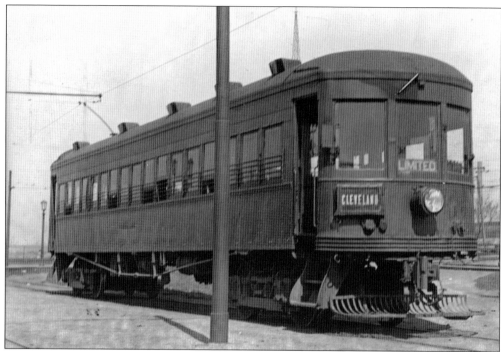

Car No. 169 waits at the East Ninth Street Pier (known to Clevelanders as the site of Captain Frank's Seafood Restaurant). Car No. 169 was rebuilt and refurbished by LSE at the Sandusky shops after suffering heavy damage in a fire at Beach Park on April 15, 1918, and was in regular service taking passengers to East Ninth Street, where these passengers would board the C&B ships to Buffalo and Niagara Falls. This was an advertised "honeymoon" trip.

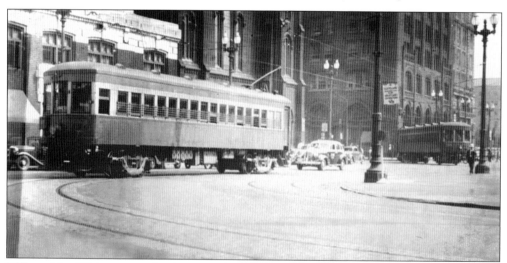

LSE car No. 176 is seen in the foreground, and car No. 180 is in the background. These cars are handling their normal duties, making the right turn off East Ninth Street in Cleveland, around Public Square and off to Toledo. The first car is the express, and the second is the Toledo local. The Old Stone Church can be seen to the left, with the Society for Savings in the back right. This photograph is from either 1936 or 1937, as the Great Lakes Exposition sign is on the lamppost to the right.

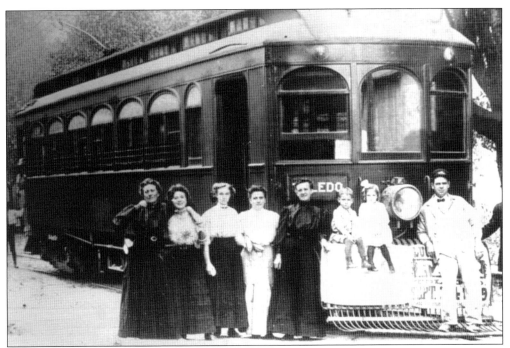

This early publicity shot is showing the people who rode the interurban. At least the people that the owners wanted the public to believe rode the interurban. In reality, everyone rode the interurban, as it was not unusual for the LSE to move 20,000 people in any given day at the height of operations.

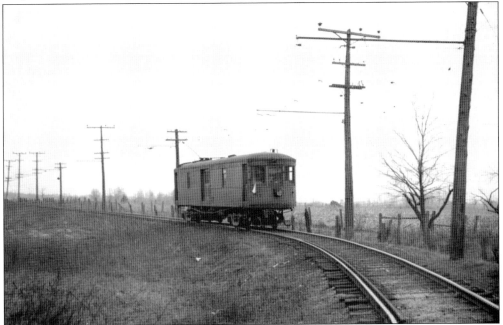

Freight motor car No. 37 approaches Ceylon Junction coming from Berlin Heights on the southern division. The move is white flagged as a nonscheduled extra and could be hauling fresh-picked fruit and vegetables to markets in Cleveland or Toledo.

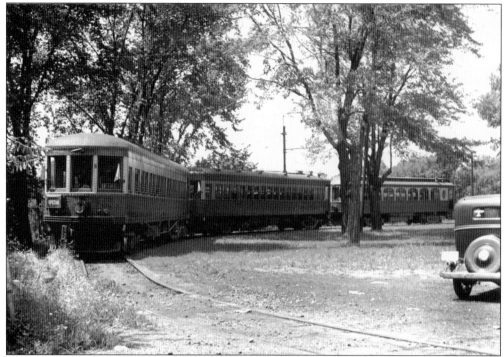

LSE car No. 182, car No. 179, and car No. 155, assigned to an extra baseball special run from Lorain to League Park in Cleveland, sit in the turnaround loop at Cleveland Railways Rocky River Carbarns in 1937. The streetcar track to League Park was the old Payne Avenue line, some of Cleveland's oldest, and it would not take the big heavy interurban cars so passengers were transferred to streetcars for the trip downtown.

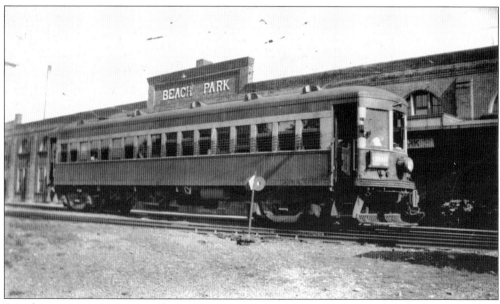

Seen here at stop No. 65, a westbound Jewett steel car waits for passengers to board at Beach Park on a sunny summer day.

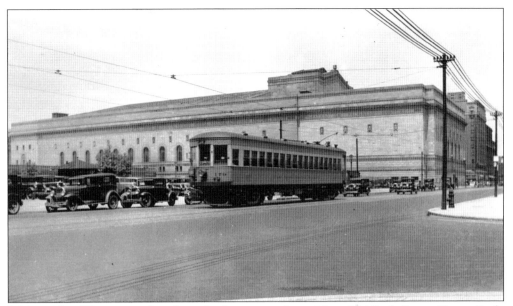

LSE car No. 179 is proceeding from the layover track at either the Ninth Street Pier or Eagle Avenue and comes down Ninth Street to St. Clair Avenue and turns south on Ontario Street to get to the interurban station on Public Square.

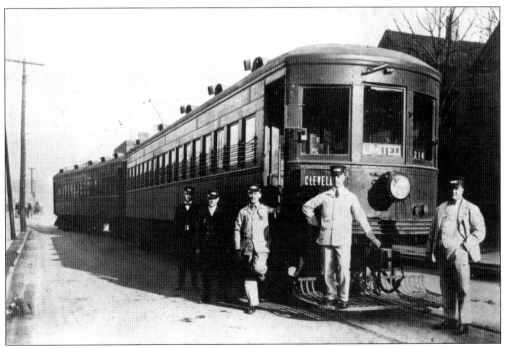

LSE car No. 181 and LSE car No. 169 are trained together in this pre-1925 photograph in Detroit, ready to make a limited run to Cleveland. The crew from the DUR is ready to take the cars to Toledo to be picked up by LSE crews and taken on to Cleveland.

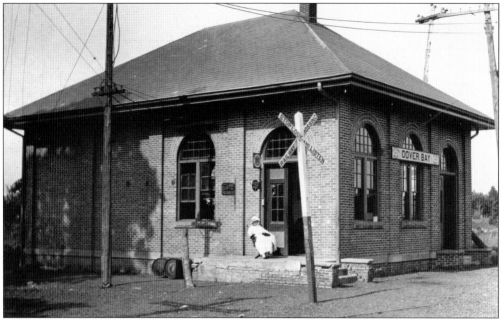

The station/substation at Dover Bay is seen here at stop No. 13 at Clague Road. The station attendant's wife is enjoying the fine weather.

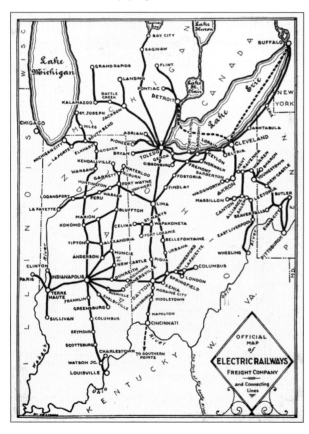

The official connections map of the Electric Railway Freight Company shows the ultimate expansion of the interurban freight network.

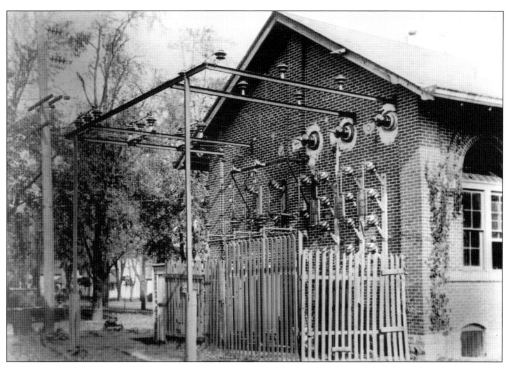

This photograph shows the back of the station/substation at Genoa. Behind the fence are the high-voltage alternating current transformers that were moved outside at all LSE facilities after the Beach Park fire in 1922.

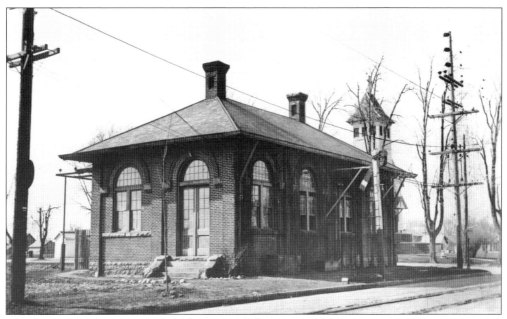

This LSE inventory picture shows the station/substation at Genoa.

This aerial view of the harbor at Huron Harbor shows the railroad and dock facilities are WLE. This picture was taken after 1918 and shows the new Route 2. The LSE ran along the north side of the highway.

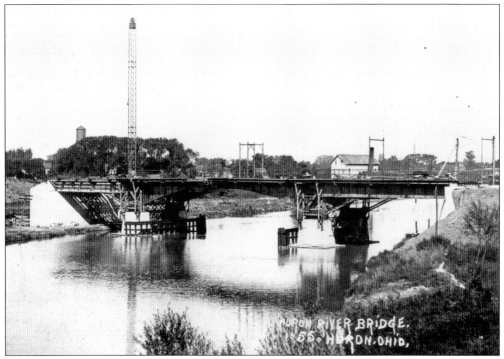

The "new" bascule bridge over the Huron River replaced the rickety downtown bridge for the new Huron Cutoff in 1918.

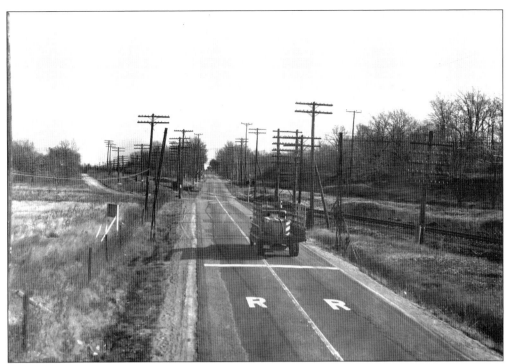

This picture was taken on Route 2, east of Vermilion, at Elberta Beach stop No. 127. A very dangerous crossing with the Nickel Plate Railroad main line is seen in the foreground with the LSE track behind it. This is now the site of a rather large and ungainly highway overpass that eliminates crossing hazards.

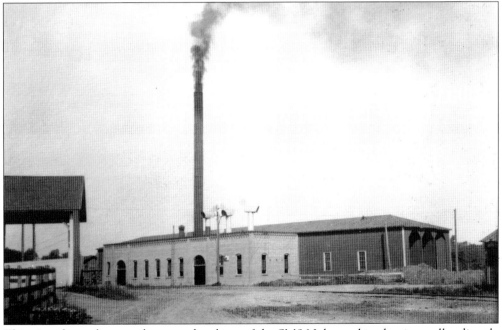

This view shows the powerhouse and carbarn of the SM&N, located in the river valley directly north of Milan.

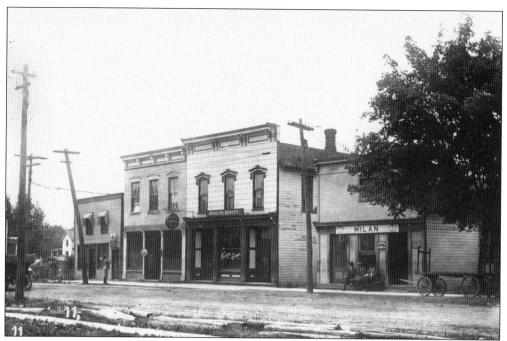

This is a picture of the LSE station in Milan. Three potential passengers wait on the next car while a motortruck putts away to the left, already stealing business from the railroad.

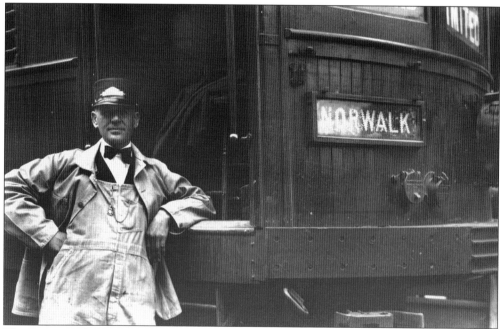

This pre-1925 photograph is of a smiling motorman with his elbow resting on the front doorsill of an LSE Niles car. The early car signage indicates a Cleveland-bound limited running on the southern division through Norwalk to Ceylon Junction.

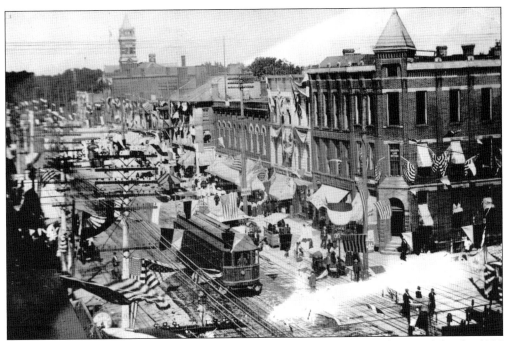

This eastbound B&S car waits at the station in Norwalk. The town is decorated for the 1909 centennial celebration.

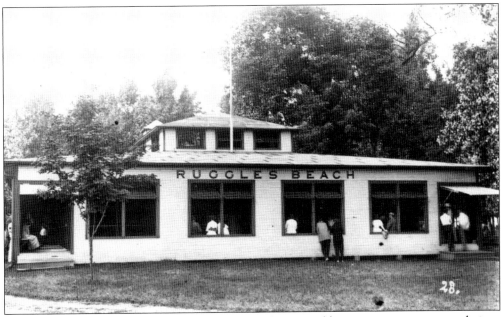

Stop No. 150 was at Ruggles Beach, west of Vermilion. In addition to tourist accommodations and a fine beach, a dance hall was provided for those who wished to trip the light fantastic to the tunes of traveling bands, big name and small name, that toured the Lake Erie shores summer circuit.

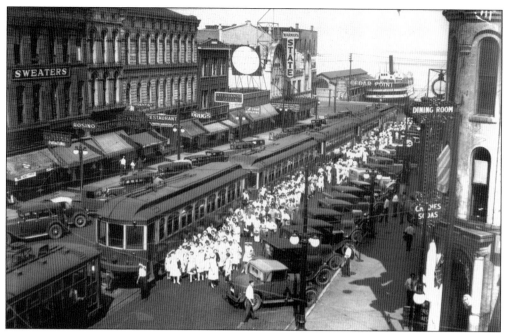

The scene is of the Columbus Avenue interurban station in Sandusky. The season is the fall, and Cedar Point has closed for the year. The five chartered interurban cars have delivered around 400 4-H members and their advisors for an excursion via the steamboat *Chippewa* to the 4-H camp at Kelley's Island.

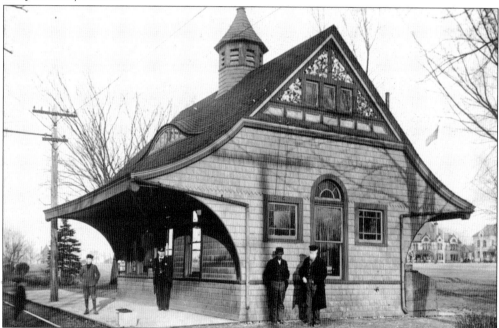

This is the LSE station at the Sandusky Soldiers Home. In order to qualify for the site, Sandusky promised direct streetcar service to this out-of-town location on the south side of Sandusky, now known as transit-oriented development. As the LSE grew, it used this track to get downtown so the home residents had interurban as well as streetcar service.

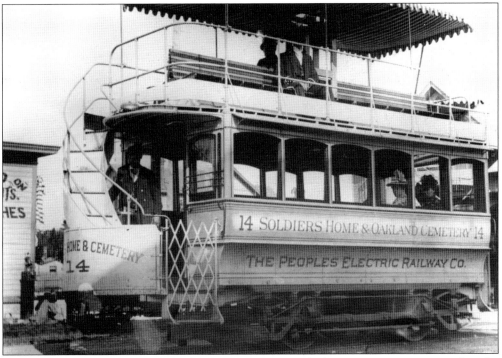

Double-decked Peoples Electric Railway car No. 14 is ready for a summer outing to either the Sandusky Soldiers Home or Oakland Cemetery.

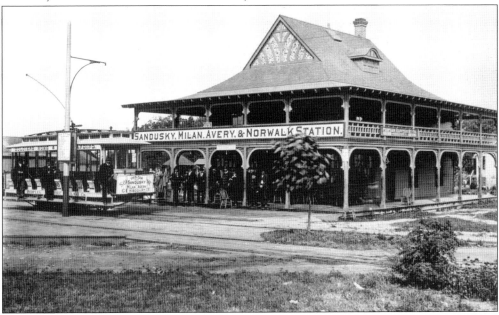

When the construction of the SM&N was completed, the interurban cars that had been ordered from Jewett Car Company were not ready. Itching to get into operation, streetcars from the parent company, Peoples Electric Railway, were pressed into service. This picture shows one of these cars in front of the station, which was right across the street from the Sandusky street railways station at the Sandusky Soldiers Home.

This is the third and final interurban station in Sandusky, with the ubiquitous penny scale in front. The small child holding hands with his mother is related to the family whose railway experience in Sandusky included the first horsecars right up through the LSE.

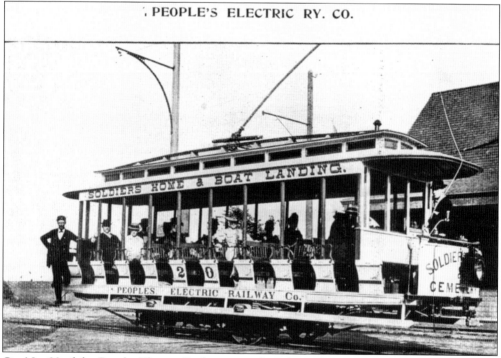

Car No. 20 of the Peoples Electric Railway is ready to leave from the Sandusky Soldiers Home station and head down to the boat docks at the foot of Columbus Avenue in Sandusky.

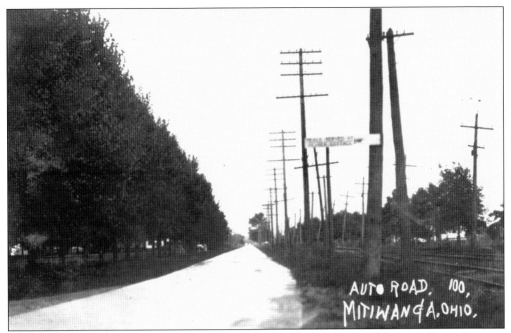

Between Mitiwanga (stop No. 149) and Ruggles Beach (stop No. 150), Ohio Route 2 was a concrete all-weather road stretching between Cleveland and Toledo, deadly competition for the interurban passenger and freight business.

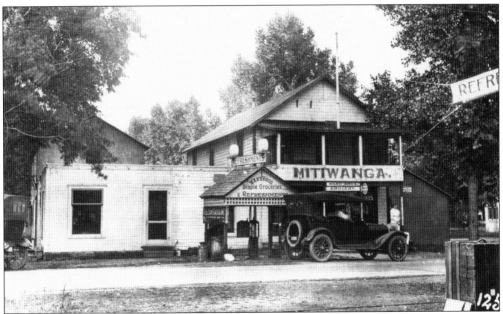

Here is stop No. 149 across from Ward Brothers Grocery and gas, with a pool hall and bowling, in Mitiwanga. In the right foreground is the edge of a steamer trunk waiting for pickup by the LSE—another vacationer goes home for the summer.

This view of Ceylon Junction, from the north side of old Route 2, looks west. The Otto family's refreshment stand and gas station with the LSE main line can be seen behind it. Today the lake has eroded the highway away back to the old track line and the junction building is now lakefront property.

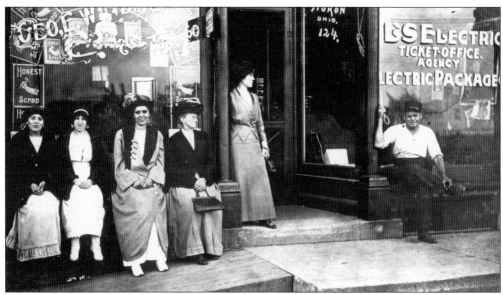

Of all the photographs of this era, none capture it so well as those of Ernst Niebergall. Station agent George Windau and a group of Huron women are pictured here waiting for the next LSE car on the benches in front of the station.

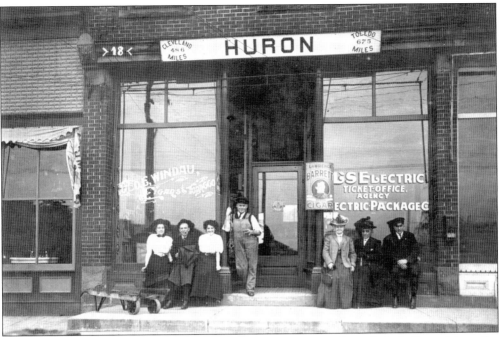

Again, Niebergall captures the station agent with a new group of people including a lake sailor waiting for the next car.

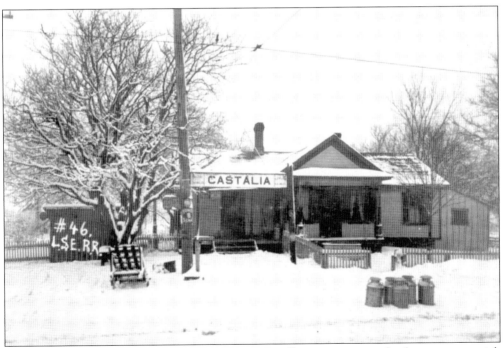

Stop I is seen here in Castalia in the dead of winter. Milk cans are set out for the next car to pick up, and any passengers are waiting inside where it is warm.

This very colorful advertisement placard was used by the LSE, along with a number of other high-color, attention-grabbing marketing pieces.

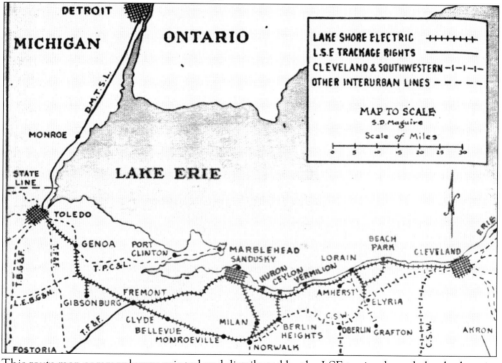

This route map commonly was printed and distributed by the LSE to simply and clearly show its routing and interchange capabilities.

What most people remember about the LSE is the recreational areas served, especially the parks, listed here.

RESORTS

At CLEVELAND you find some of the finest parks and places of amusements to be found anywhere. Gordon Park, about four miles east of the public square on the banks of Lake Erie, is a beautiful park with fine drives and just the place for Sunday School Picnics or a day's outing. Wade Park about the same distance from the square is connected with Gordon Park by the Boulevard which encircles the entire city, Luna Park and Edgewater Park and others which cannot be mentioned, as space will not permit. Running along the shore of Lake Erie more resorts are reached by this line, than by any other line running out of Cleveland or Toledo.

BEACH PARK situated on the banks of Lake Erie, between Cleveland and Lorain, is an ideal spot for a picnic, or a day's outing. It is provided with a large pavilion, with a dancing hall, 5,000 square feet, bowling alley, pool and billiard room, ball ground, bathing, boating, merry-go-round, shooting range, and the usual attractions found at a resort of this kind.

LINWOOD PARK Vermillion, is one of the finest groves to be found along the shore, and is one of the most desirable spots for a Sunday School Picnic or a Summer Home. Besides the Three Story Hotel, there are 80 cottages for the accommodation of those wishing a nice quiet place.

CRYSTAL BEACH Vermillion, adjoins Linwood Park and is equipped with all modern, up to date improvements usually found at resorts of this kind.

RUGGLES GROVE and MITIWANGA situated between Vermillion and Huron, are noted for their fine summer homes, dancing pavilion, bathing and boating.

SAGES GROVE situated east of Huron, is a large grove owned by this company, and is an elegant place for campers having their own tents and camp outfits.

RYE BEACH situated between Huron and Sandusky, is one of the most desirable places for picnics and summer homes. Many fine cottages are now occupied and many more being built each season.

At SANDUSKY there are numerous points of interest. The Soldiers' Home, situated just outside the city limits, can be reached from any point in the city by trolley.
Kelley's Island, Middle Bass, Put-in-Bay, Lakeside and Marble Head, are also reached by boat from Sandusky.

CEDAR POINT the queen of American water places, has the most attractive hotels on the Great Lakes. The mammoth hotel, The Breakers, is one of the largest summer hotels in America, covering over eight acres of ground and contains a thousand rooms, every one of which is an outside room. The Beach is the finest, safest, and most perfect in the world, for bathing and boating. It is also equipped with all the most modern improvements and attractions to be found at a first class resort. Boats leave Sandusky for Cedar Point every half hour.

TOLEDO in itself has all that can be desired to amuse its growing population. Lake Erie Park and Casino, six miles from the center of the city, has a mammoth Casino built out into the Lake, where refined Vaudeville is given afternoons and evenings. The Farm is another resort where Vaudeville is presented daily. Toledo Beach, about fifteen miles from the center of the city, is a very attractive park and has one of the finest bathing beaches to be found. Walbridge Park, with Bellevue Park adjoining, presents the appearance of a great White City and a favorite spot for excursionists and others who desire attractions of all kinds.

Lake Shore
Interurban Cars

Cleveland
Station—No. 25
Public Square

Toledo
Station—No. 348
Superior St.

leave from downtown
Cleveland
and
downtown
Toledo

CONNECTIONS

TOLEDO—Eastern Michigan Railways, Toledo & Western Ry. Toledo & Indiana Ry. Toledo, Bowling Green & Southern Ry. Toledo, Fostoria & Findlay Ry. Lima, Toledo R. R., (Cincinnati & Lake Erie R. R.), "The Short Way" Lines to Ann Arbor, Adrian, Jackson and Flint, Michigan.
And all steam roads diverging.
GENOA—The Ohio Public Service Co.
WOODVILLE—Pennsylvania Ry.
FREMONT—Fostoria & Fremont Ry. (Electric). Wheeling & Lake Erie R. R., Nickel Plate R. R.
CLYDE—Cleveland, Cincinnati, Chicago & St. Louis Ry.
BELLEVUE—Nickel Plate, Pennsylvania.
MONROEVILLE—Baltimore & Ohio R. R.
NORWALK—Bus to Shelby, Mansfield, Plymouth, Willard and Shenandoah.
And steam roads diverging.
SANDUSKY—Lake Shore Coach Co., (motor bus service) to Bogart, Avery, Milan and Norwalk. Boat Line connections for Cedar Point, Lakeside, Kelly's Island, Middle Bass, Put-In-Bay, Bay Point, Pelee Island (during season of navigation).
And steam roads diverging.

This is the 1930 LSE time schedule. The photograph on the front cover shows that the LSE kept up with the times, in contrast to its older engraved covers, to display its trademark three-car trains.

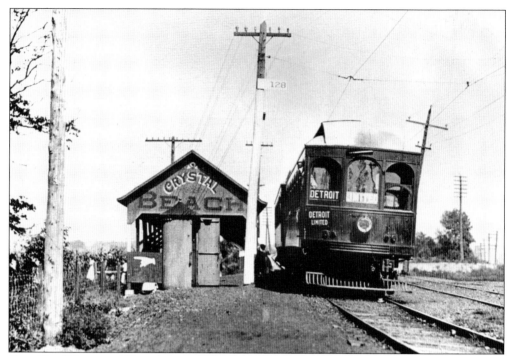

Stop No. 128, east of Vermilion, was the stop for Crystal Beach and Linnwood Park, a hefty half-mile walk to the lake road. LSE car No. 148 leads a two-car train as a Detroit Limited. The motorman waits in the doorway while the conductor is in the circular telephone booth calling the Sandusky dispatcher for the OK to proceed.

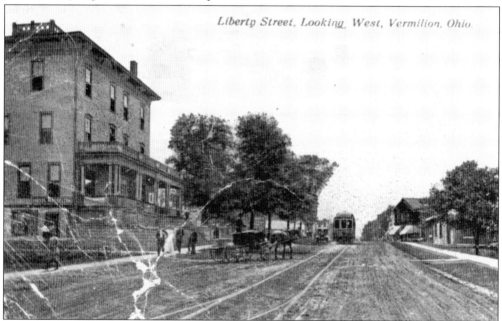

Liberty Street, Looking West, Vermilion, Ohio.

This photograph was taken at East Liberty Avenue in Vermilion. An LSE Brill is eastbound down the hill to the station. The Hotel Maudelton is next to the LSE Vermilion station/substation, both of which are still there today.

Four

THE END OF THE LINE

The court-ordered auction of LSE assets occurred on January 4, 1938. The only bidder in attendance was the finance company that was owed $312,015. In order to mitigate its loss, the firm attempted to operate the railway for an experimental period, in an attempt to develop a profit. The remaining employees attempted to obtain the necessary financing to purchase the railway and operate it as an employee-owned venture, but were unable to find capital. The continued operation proved to do nothing but add to the debt, and May 14, 1938, marked the last interurban run from Cleveland to Toledo. Many of the employees were upset to find that the longtime president of the LSE, F. W. Coen, was actively working against their efforts. They did not fully understand his resistance to their efforts to purchase the line, as everyone knew that the Cleveland–Lorain operation continued to be profitable. What the workers did not understand was that Coen was continuing in the transportation business, as the principal of the Lake Shore Coach Company, a bus service that took over service previously provided by the LSE.

The railway equipment was virtually worthless, other than scrap. It must be remembered that the closure of the LSE was not in a vacuum. Around the United States, virtually all interurbans were closing. Only three railcars were sold as operating units. Jewett cars No. 170, No. 179, and No.180 went to the Des Moines and Central Iowa Railway.

The rest of the units ended up on the "Dead Line" at Sandusky or Fremont, where the scrap steel from the wheels and much of the tracks was sold primarily to Japan, which was the main market in 1938. The car bodies were sold to local individuals and businesses for use as cottages, storage facilities, diners, and residences.

SEE INSIDE PAGES FOR LAKE SHORE
ELECTRIC RAILWAY COMPANY MAIN LINE
TIME TABLES

— CONNECTIONS —

CLEVELAND—Penn-Ohio Coach Lines to Akron, Canton, Warren, Youngstown. C. & B. Transit Co. (boat) to Buffalo, Pt. Stanley, Niagara Falls. All eastern steam railroads.

TOLEDO—Cincinnati & Lake Erie R. R. to Lima, Dayton, Cincinnati, Springfield, Columbus. Motorbus to Detroit via Safeway Lines, and Eastern Michigan Motorbus Co. "The Short Way" Lines (bus) to Adrian, Flint, Ann Arbor, Jackson.

SANDUSKY—Bus to Ashland, Mansfield, Milan, Shelby, Bucyrus, Marion, Delaware, Columbus and southern Ohio points, Buckeye Stages, Inc., also to Port Clinton, Lakeside, Marblehead, Boats Mascot and Messenger to Kelley's Island, Lakeside, Middle Bass, Put-in-Bay. Steamer Pelee to Pelee Island, Canada, on Fridays only.

LORAIN—Lorain Street Railroad to South Lorain and Elyria. Lake Shore Coach to Penfield, Amherst and Elyria.

FREMONT—Findlay-Fremont Bus to Fostoria, Findlay and intermediate stations. Tiffin-Fostoria bus to Tiffin.

BELLEVUE—Nickel Plate Railroad. Pennsylvania R. R.

GENOA—The Ohio Public Service Co.

F. W. COEN, Receiver

THE
LAKE SHORE
ELECTRIC RAILWAY
Fast Interurban Service

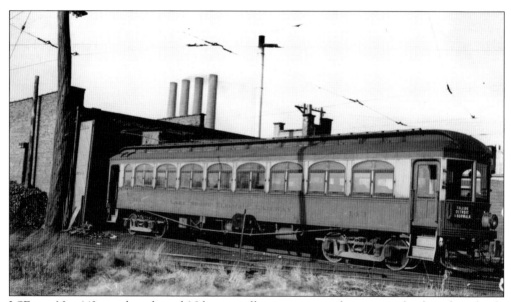

Time Schedules
CLEVELAND — TOLEDO
VIA
LORAIN, SANDUSKY, FREMONT
Vermilion, Huron, Norwalk, Bellevue
and Intermediate Stations
IN EFFECT SEPT. 20, 1937

BARGAIN LOW FARES

2c per mile one way 1½c per mile round trip

L. K. BURGE E. K. HARTZELL
Gen'l Supt. SANDUSKY, OHIO Gen'l Pass. Agt.

This 1937 timetable illustrates the efficient cost of transportation even when the railway was in the final months of operation.

LSE car No. 143 is a lengthened Niles car, allowing increased passenger load, and is clearly post-1937, as one can see the lowered headlamp and below-floor light demanded by the Public Utilities Commission of Ohio. This unit was lengthened in 1923 at the LSE Sandusky shop.

114

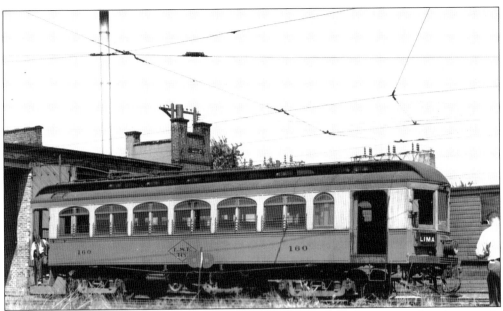

LSE car No. 160 is a Niles car, built in 1907, located at the Beach Park station in this photograph. This was a combine car, which handled passengers and freight. Note that the freight/baggage section is from the large sliding door to just past the half window. The person who took this photograph at the Beach Park station in 1937 is a railfan. He probably changed the destination sign, as the LSE did not run to Lima in 1937.

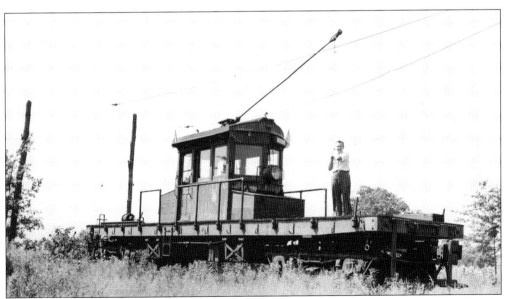

This 400-series work motor was used for general switching, plowing, wreck removal, and use by the section crews. The gentleman shown is a railfan, suggesting that this photograph is near the end of operations.

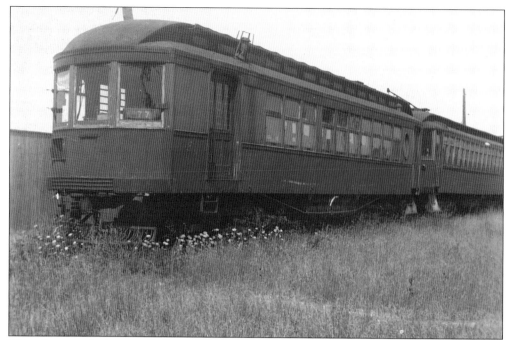

This photograph shows a Brill combination on the dead line awaiting removal of trucks for scrapping and sale of the body for local use as a cottage, storage unit, and so on. The 60-series Brill manufacturing cars were combination units, which carried both passengers and freight. For example, a standard rate for newspapers from Toledo to the various stations was 50¢ per hundredweight. This particular unit was modernized at the LSE Sandusky shop.

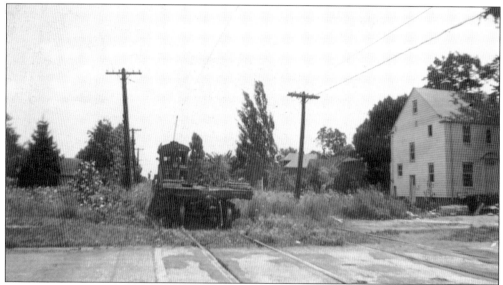

This LSE 400-series work motor is operating in Bay Village, pushing a flatcar. Note the overgrown condition of the right-of-way, allowing the knowledge that this is at the end of operations. F. W. Coen kept the LSE workers active through 1939, in order to allow them to gain time in their railroad retirement system. This combination of work motor and flatcar was common when the scrapping operation was in full swing, 1938 and 1939.

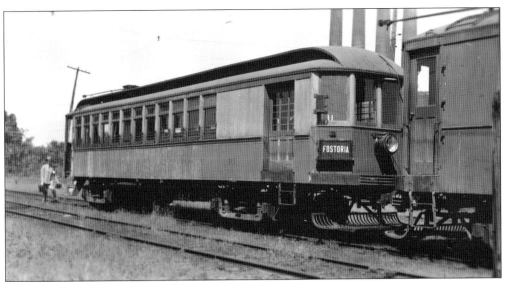

LSE car No. 16, built in 1900, is looking pretty good in this 1937 photograph. However, one year later the trucks were sent to Japan and the body ended up at 34961 Detroit Road in Avon. It was used as a diner, gas station, and ice-cream stand. It burned in November 1978.

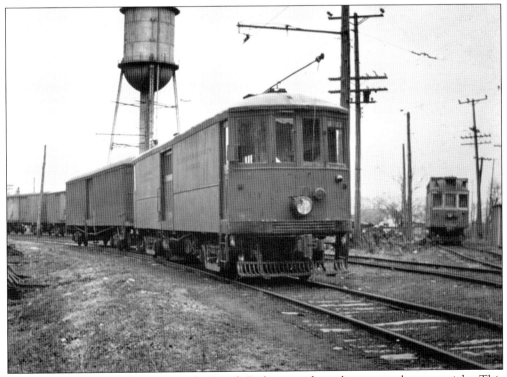

This original B&S freight motor at the Beach Park station has a line car to the upper right. This was probably photographed in 1937 or 1838.

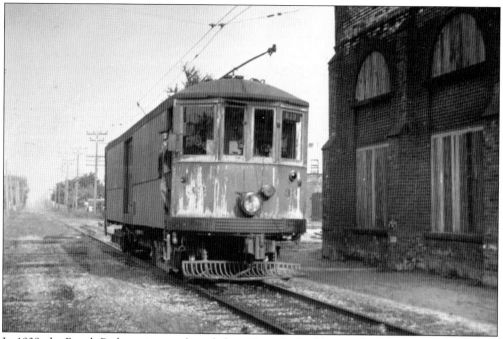

In 1939, the Beach Park station was boarded up. Even the building and car look sad on the single remaining track. LSE car No. 33 was the switcher between Beach Park and the west side of Lorain. This unit remained in operation up to the final closing of the LSE.

LAKE SHORE ELECTRIC RAILWAY
CLEVELAND-TOLEDO, 1893-1938

SPEED COMFORT
L.S.E. RY.
SAFETY SERVICE

AROUND 1900 THE BIG ORANGE TROLLEY CARS OF THE LAKE SHORE ELECTRIC RAILWAY CARRIED PEOPLE THROUGH THIS AREA AT 60 MILES PER HOUR. BEFORE THE AUTOMOBILE BECAME POPULAR, THIS INTERURBAN TROLLEY FILLED THE NEED FOR FAST, EFFICIENT AND SAFE TRANSPORTATION. THE L.S.E. RY. WAS THE MAJOR SPARK FOR THE EARLY GROWTH AND PROSPERITY OF AVON LAKE.

THERE ARE STILL SOME RAILWAY LANDMARKS AROUND TODAY THAT YOU CAN SEE ALONG THE LAKE SHORE BIKE ROUTE: THE TROLLEY BARN, BRIDGE RUINS AND PARTS OF THE ORIGINAL ROADBED. IN AVON LAKE, THE RAILWAY WENT ALONG ELECTRIC BLVD. THE SADDLE INN BUILDING SERVED AS AVON BEACH PARK STATION AND ALSO AS THE TROLLEY BARN. AVON BEACH PARK WAS LOCATED AT THE SITE OF THE PRESENT C.E.I. POWER PLANT. THE RAILWAY POWER PLANT WAS JUST EAST OF THE PARK. FAMILIES WOULD RIDE THE TROLLEY OUT TO AVON BEACH PARK FOR A DAY OF SWIMMING, PICNICING, ORGANIZED BASEBALL AND GAMES. MANY A ROMANCE BLOSSOMED AS COUPLES DANCED IN THE PARK PAVILLION UNTIL THE LAST TROLLEY AT MIDNIGHT.

This commemorative marker is located at the Avon Lake Floral Park located at the entrance to the Beach Park station, just west of Moore Road on Electric Boulevard.

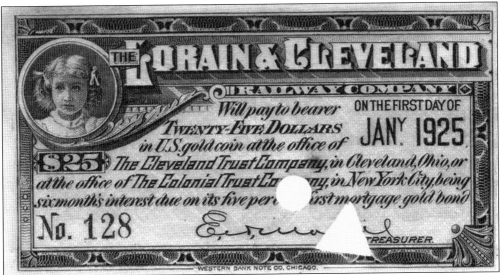

This coupon was issued in January 1925 by the L&C (an entirely owned subsidiary of the LSE). The little girl looks worried. Her worry was confirmed when LSE defaulted on this issue.

ON THE FIRST DAY OF JANUARY, 1927

The Lake Shore Electric Railway Company will pay to the bearer **THIRTY DOLLARS,** **$30.00**

In gold coin of the United States, of the present standard of weight and fineness, at the office of the Union Trust Company in the City of Detroit, Michigan, being six months' interest then due on the First Mortgage Twenty-Year Gold Bond of The Toledo, Fremont & Norwalk Railroad Company, as extended by the terms of an agreement between The Lake Shore Electric Railway Company, Union Trust Company, Trustee, The Guardian Savings and Trust Company, Depositary, and the bond holders, dated January 1, 1925.

TREASURER.

Bond No.

322

Coupon No.

4

This negotiated bond coupon, issued by the LSE, indicates the debt incurred when the Evertt-Moore Syndicate purchased the Toledo, Fremont and Norwalk Railroad Company.

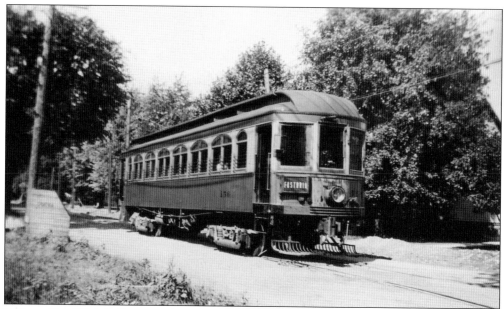

LSE car No. 156 is in Fremont, on a shop track located at Fifth Street. This particular run was a fan trip in 1937. This is one of the Niles cars. Electric railway fans were active in purchasing excursion on the interurbans, normally purchasing the entire nonscheduled run for themselves and their "Juice fan" friends.

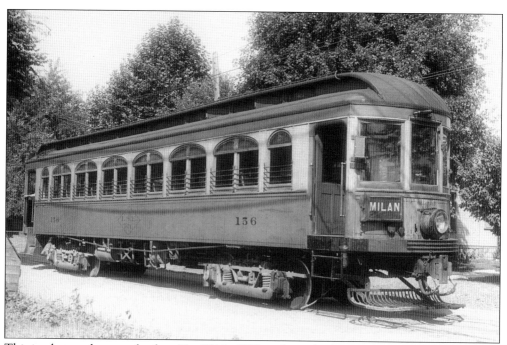

This is a better photograph of car No. 156 in 1937, without the fan passenger in the photograph. This was also taken in Fremont.

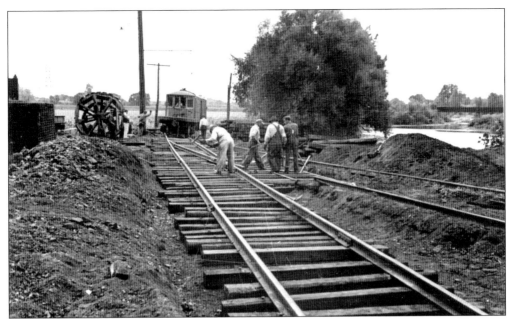

This 1938 photograph is somewhat confusing at first look. This is the end of the line, but this crew of gandy dancers is laying new track. The reason is two-fold—the track is needed to bring the cars, equipment, and track to the Fremont carbarn for scrapping, and also this busy work allowed by F. W. Coen helped the workers to gain an extra year or two to their railroad pensions.

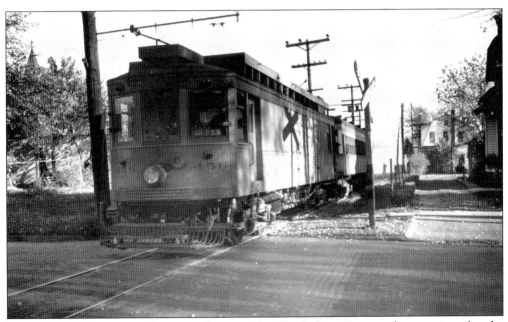

Line car No. 456 is towing a Jewett steel car to either Sandusky or Fremont for scrapping after the line ceased operation at an unknown location. Evidently the passenger car could not run under its own power and was being towed to its destruction.

Taken in 1965, this photograph shows the concrete piers of the Berlin Heights Trestle soaking up the sun 27 years after the line was torn up. The concrete, reinforced with ancient Lorain streetcar rail, is still standing to this day.

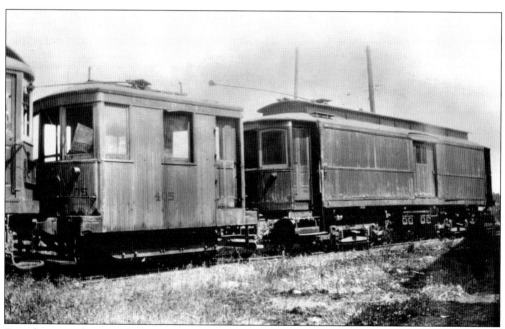

Seen here on the "Sandusky Dead Line," LSE car No. 405, the Beach Park Shunter keeps LSE car No. 41, original L&C express car company, as they await the scrapper in Sandusky in 1939.

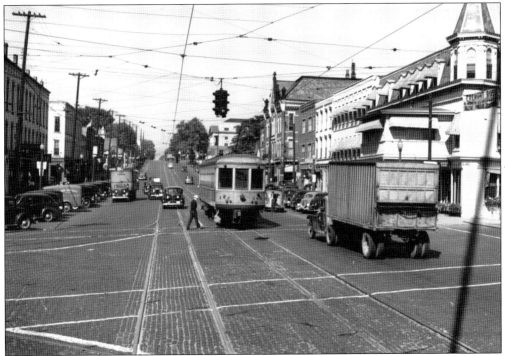

LSE car No. 182 leaves Fremont westbound. The date is September 9, 1937.

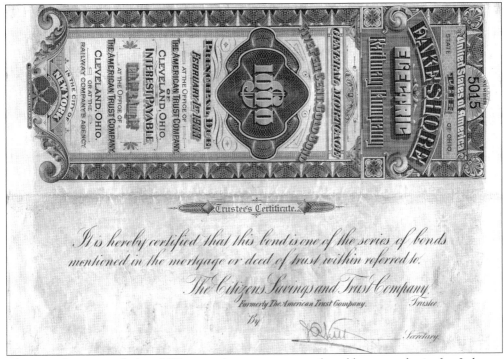

The proud owner of this LSE general mortgage may be able to trade it for Lehman Brothers stock.

This is the end of the line. The location is the station in Lorain, the car is LSE car No. 167 at the end of the last run, and the crew is conductor E. R. Jamieson and motorman James Trimmer on May 15, 1938. The destination sign is already set for the last trip back to Beach Park.

LSE car No. 168 is on a layover on West Third Avenue in Cleveland. This winter run shows this car waiting to head out in 1937. A railfan has turned to destination sign to "Elyria," an Avon Beach and southern destination discontinued in 1924.

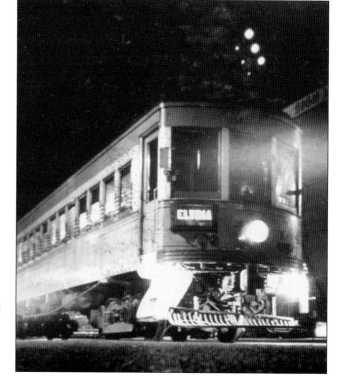

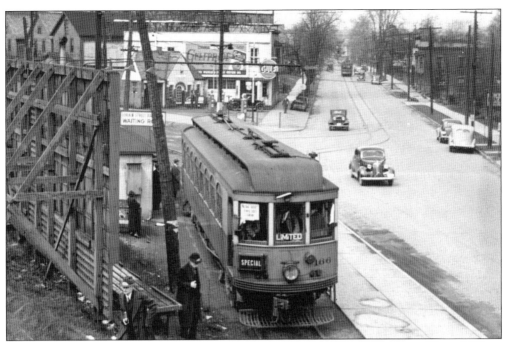

The date is May 3, 1938, the place is the Lorain Street Railroad (LSRR) station in Elyria. LSE car No. 166 made the trip down the LSRR from Lorain to Elyria as part of the last fan trip on the LSE. The railfans are out and about taking pictures while a LSRR car speeds down Lodi Street on its way to Lorain. The turnaround wye replaces the original loop to keep the cars off the roadway.

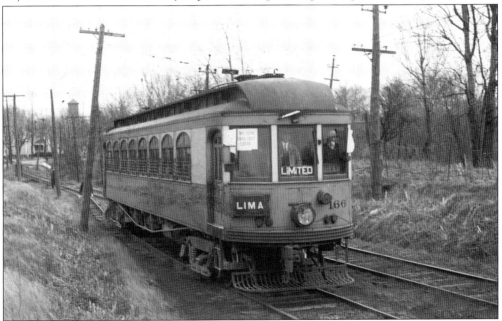

Taken on the last fan trip over the LSE, car No. 166 sits on the east end of siding near stop No. 129, Bluebird Beach, waiting for the eastbound car to pass. In the background is the western edge of Vermilion and the end of Liberty Avenue. This entire site is now buried under the "new" road.

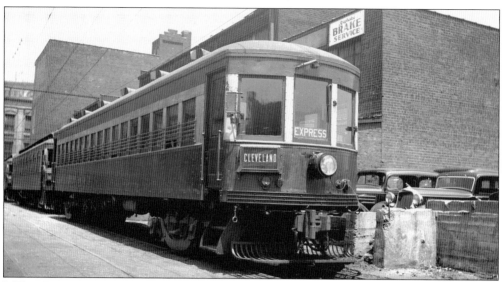

LSE car No. 170 is at Eagle Avenue in Cleveland waiting for the next run. The date is May 25, 1935.

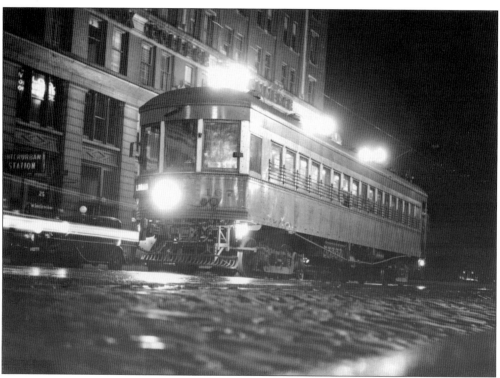

LSE car No. 167 sits in front of the Cleveland interurban station as the last car to run on the LSE, ending the interurban era in Cleveland on May 15, 1938.

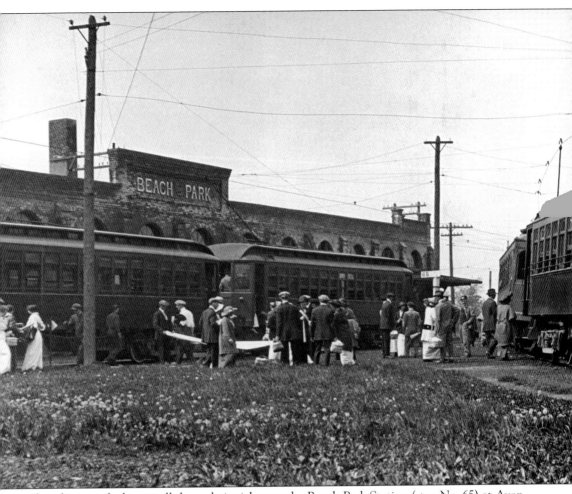

This photograph shows well-dressed picnickers at the Beach Park Station (stop No. 65) at Avon Lake. The dance hall, beach, rental boats, and campgrounds on the wide Avon Beach Park of Lake Erie helped the LSE move as many as 20,000 passengers per day.

DISCOVER THOUSANDS OF LOCAL HISTORY BOOKS FEATURING MILLIONS OF VINTAGE IMAGES

Arcadia Publishing, the leading local history publisher in the United States, is committed to making history accessible and meaningful through publishing books that celebrate and preserve the heritage of America's people and places.

Find more books like this at
www.arcadiapublishing.com

Search for your hometown history, your old stomping grounds, and even your favorite sports team.

Consistent with our mission to preserve history on a local level, this book was printed in South Carolina on American-made paper and manufactured entirely in the United States. Products carrying the accredited Forest Stewardship Council (FSC) label are printed on 100 percent FSC-certified paper.

MADE IN THE USA